THE ART
OF SPRAY
PAINT

Quarto is the authority on a wide range of topics.

Quarto educates, entertains and enriches the lives of our readers—enthusiasts and lovers of hands-on living.

www.QuartoKnows.com

First published in the United States of America in 2017 by
Rockport Publishers, an imprint of
Quarto Publishing Group USA Inc.
100 Cummings Center
Suite 406-L
Beverly, Massachusetts 01915-6101
Telephone: (978) 282-9590
Fax: (978) 283-2742
QuartoKnows.com
Visit our blogs at QuartoKnows.com

10 9 8 7 6 5 4 3 2 1

ISBN: 978-1-63159-146-4

Digital edition published in 2017
eISBN: 978-1-63159-206-5

Library of Congress Cataloging-in-Publication Data
Names: Zimmer, Lori, author.
Title: The art of spray paint : inspirations and techniques from masters of aerosol / Lori Zimmer.
Description: Beverly, Massachusetts : Rockport Publishers,
an Imprint of Quarto Publishing Group USA, Inc., [2017] | Includes index.
Identifiers: LCCN 2016025058| ISBN 9781631591464 (softbound) | ISBN 9781631592065 (eISBN)
Subjects: LCSH: Airbrush art--Technique.
Classification: LCC NC915.A35 Z56 2017 | DDC 751.4/94--dc23
LC record available at https://lccn.loc.gov/2016025058

Design: Laia Albaladejo
Front Cover Images: PichiAvo, Joe Iurato, and Ele Pack
Back Cover Images: Remi Rough, Crash, and Casey Gray
Back Flap Image: ROA

Printed in China

THE ART OF SPRAY PAINT

Inspirations and Techniques from Masters of Aerosol

LORI ZIMMER

ROCKPORT

INTRODUCTION: THE BEGINNING OF SPRAY PAINT

Spray paint only came into existence in 1949, when a paint salesman from Illinois experimented with creating a better way to apply aluminum coating to radiators. At the suggestion of his wife Bonnie, Ed Seymour combined paint with existing aerosol technology, creating the world's first spray paint can. For the next few years, spray paint remained solely a utilitarian tool in the industrial realm. Then in 1953, Robert Abplanalp invented a clog-free nozzle, giving users a more controllable spray. The increasing availability of spray paint from brands such as Seymour, Krylon, and Rust-Oleum gradually began to gain the attention of artists, who were attracted to the immediacy and power of the aerosol can.

The iconic arrangement of oil paints on a palette has a certain air of prestige that many consider a necessary part of an artist's oeuvre. Using oil paints is a meticulously controlled process, from mixing pigments to careful brush painting, to the prolonged period of time needed for each layer to dry. The painter is always in control, with a direct line from fingers to brush to canvas.

Spray paint, on the other hand, offered traditional fine artists the freedom of spontaneity, fueled by the sensation of power that pressing the cap on a can of aerosol paint can have. With the jolt of a propellant under pressure, spray paint allowed artists to create art focused on mark making, gestural and projectile movements, and new drip and puddlelike textures that dry within seconds instead of days. Conceptually, using spray paint put a layer of removal between artist and canvas, the powerful force of spray paint meaning the artist never needed to actually touch the canvas.

A NEW MEDIUM to CONSIDER

The introduction of the spray paint can inspired a fleet of art experimenters, who used the pressurized paint as a new art tool, employing trial and error to harness control of the gaseous contents. Industrial pressurized paint guns had been used previously by artists such as Paul Klee and Man Ray, but spray paint in aerosol cans was affordable, handheld, and available to anyone without investing in specialized equipment.

In the mid-1950s and 1960s, artists began using spray paint as a way to explore hazy textural layers, produce thinner drips than oils and acrylics could, build up color without thick texture, and use objects and paper as stencils. One of the first artists to create a significant body of work using spray was David Smith, an American Abstract Expressionist sculptor mostly known for making large abstract geometric sculptures from steel. He saw the quick and mechanical process of the spray can as a way to merge drawing, painting, and sculpture with quick and controlled action.

Artist Lawrence Weiner utilized the mechanisms of spray paint to illustrate his conceptual philosophies in the 1960s. Exploring materials and their relationships to the artist, Weiner created a series of works in which he expunged the contents of a can of spray paint onto a surface, showing the results of the artist's interaction with the medium. The pieces were given obvious and appropriate titles, such as *Two Minutes of Spray Paint Directly upon the Floor from a Standard Aerosol Spray Can.*

What became most attractive to artists about the aerosol spray paint can was its quickness, accessibility, and size—an artist could easily tote more than one can in a pocket or bag. These traits made spray paint quite attractive for the genre it is most known for—graffiti.

The Mutual Rise of Spray Paint and Graffiti

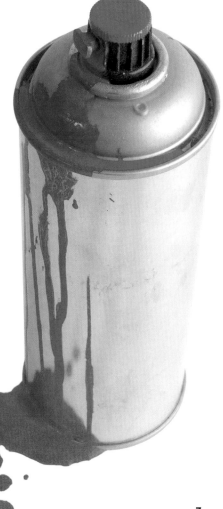

Arising in Chicago and New York in the 1970s and 1980s, the graffiti movement and spray paint flourished because of one another. What started as acts of rebellion and tagging spread to outsider subcultures such as punk rock and hip hop, and now it has reached total saturation in the genre known as Street Art or Urban Art. Graffiti, still illegal in most places, has ironically become accepted in galleries, museums, popular advertising, and mural programs that have changed the face of neighborhoods the world over.

Because of the popularity of graffiti and street art, paint companies such as Belton, Spanish Montana, German Montana, Sabotaz, and Liquitex have developed paint geared specifically toward artists. Specialized interchangeable nozzles, interestingly all produced by the LINDAL Group, give artists varying levels of can control to create myriad effects. New low-pressure cans give artists steady control, while adding more butane or methane creates high-pressure cans that produce thick and fast sprays. With an ever-increasing selection of paint colors, nozzle types, and pressurized cans, the artist's spray paint arsenal looks more like the traditional painter's palette than ever before.

Safety and Instructions

Spray paint is an affordable, multiuse art medium readily available at both art supply and home improvement stores. But spray paint takes a bit more patience and caution than traditional art mediums. Taking proper safety precautions and familiarizing yourself with the equipment will ensure a more successful project.

When getting started, it is important to take into consideration the chemical contents of the spray can, which can cause irritation in the lungs, skin, and eyes of not only the user but also those around the spray area. Before starting any project, make sure you are set up in a well-ventilated area, near a window or outside if possible. It is best to use a mask to block harmful fumes from entering your lungs. A basic respirator is available at most hardware stores for around $20 and can be used time and time again.

It is also important to be aware of your work area, as inexperienced users can create errant sprays when getting used to working with the can. Use drop cloths and cardboard to protect surfaces. And use painter's tape to protect surfaces and to block off sections on the canvas or walls.

There are several kinds of caps available that help direct your spray more easily. Fat caps are used for filling in large color fields, giving a wider spray, and should be used further away from your painting surface. Skinny caps give more precise lines

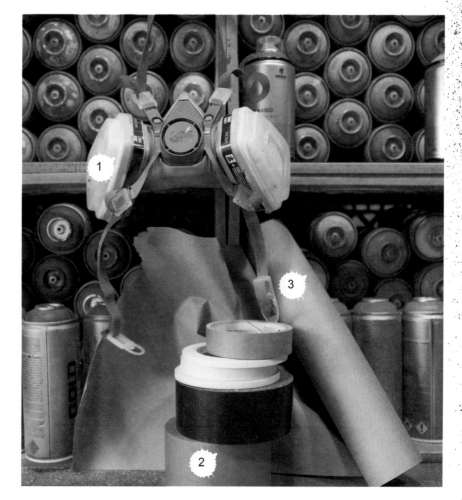

Safety tools: respirator (1), painter's tape (2), and masking paper (3)

with more directed control and are great for fine details. These two basic caps are also available in even more options, from super fat to super skinny, giving artists the control they need for specific pieces.

Working with a pressurized medium may take some time to get used to. With spray paint, practice makes perfect: give yourself time to familiarize yourself with different caps and various pressurized cans.

An easy way to delve into spray painting is to practice strokes on discarded cardboard to fine-tune can control and experiment with different caps.

1

THE ROOTS OF GRAFFITI

With roots in protest movements, British rock and roll, and hip hop culture in New York City, graffiti has helped the medium gain its place in the artist's supply cabinet. Spray paint is an obvious choice for graffiti writers. It is easy to use, portable, readily available, and—above all—can be used quickly.

From early messages spray painted on the streets to tags and eventually street art, graffiti has had a grandiose evolution that has even caused the spray can itself to change. New colors, pressures, and formulas geared specifically toward art making are constantly being offered to placate the growing number of artists trying their hand at the genre—a far cry from spray paint's utilitarian beginnings. With brilliant hues and tools for varying can control available, it is no surprise that spray paint has staked its claim among traditional art media.

Graffiti can range in style, but its methods often include quick, free-handed strokes made in haste—often on walls. Illegal graffiti, called vandalism, rose in popularity in the late 1960s and early 1970s, when tagging one's name in a signature hand style—and in as many places as possible—became a rite of passage for graffiti writers. Writers quickly developed hand styles into more artistic forms, approaching the writing of a name as visual imagery. Tags evolved into explosively colorful Wildstyle that incorporated text with color and characters, inspiring even more practitioners as artists engaged in style wars, inventing new and distinct styles of graffiti on the streets. In the 1970s and 1980s, these new styles appeared on the New York City subway trains that traveled from borough to borough, emblazoned with each artist's name for all to see before being stripped by city workers. New styles were discussed and shared at meeting places called writers' corners or writers' benches, the most famous of which was the bench in the subway station of the 149th Street Grand Concourse, where artists would gather to chat, criticize, write in black books, and trade techniques. Photographers such as Henry Chalfant and Martha Cooper made names for themselves—but also preserved important art history—by capturing new graffiti pieces on trains which were sometimes cleaned off in less than a day.

New York City's Anti-Graffiti Task Force worked hard during the 1970s and 1980s, because the rise of the genre was tied directly to the plummeting economy. Despite power-washing trains and painting over graffiti, could not hold the art form back. Its ephemerality—and the risk of getting caught—made it all the more attractive to writers and artists living across the five boroughs. Galleries such as Patti Astor's Fun Gallery opened to highlight graffiti, and artists such as Keith Haring and Jean-Michel Basquiat gained incredible popularity and success. The genre was taking root in the chronology of art history.

Some of the original graffiti writers from the 1970s and 1980s are still prolific today, with many finding successful careers in the fine art world. The genre may have branched out to include sticker culture, wheat pasting, yarn bombing, and other acts of guerilla art, but spray painting is still the central focus and artistic weapon of choice for artists both young and old.

The artists in this chapter touch on points from the early days of spray paint graffiti. John Matos, known as Crash, may have started at the dawn of graffiti in the late 1970s, but he continues to work in the genre today. Crash and his generation continue to inspire new graffiti artists—even those born decades after subway trains in New York were covered in tags. Branden Rodriguez, known as BR163, is part of the new class of artists looking to the Wildstyle pioneers of the '70s and '80s for inspiration. Other artists use graffiti as a jumping-off point, blending it with their own influences to help it evolve. For example two artists from Spain, Pichi and Avo, create their own fusion of graffiti with classical art history, making a new style that has elevated graffiti for the academic set.

DIY

Painting a Graffiti Character with BR163

Over the years, graffiti artists have developed signature characters to accompany, or even replace, their Wildstyle tags. Characters are often bubbly, with large color fields that require switching between differently sized caps. Bronx-based artist BR163's smiling, Buddha-faced character, Mr. Wonderful, has become synonymous with his signature. Here the artist shares his tips for making a bold and colorful graffiti-inspired character piece on a wall. In this case, Mr. Wonderful's smiling face melts alongside a clock for a Salvador Dalí–inspired piece.

About the Artist

Bronx-based BR163 is part of the graffiti new school, combining graf history with innovative skills. Inspired by a happy Buddha, Mr. Wonderful has become the artist's calling card, and was the subject of a 2015 solo exhibition in New York City. Before beginning each wall, BR163 sketches ideas in his notebook, then chooses the perfected image to transfer to a large scale. Follow his steps to create your own Mr. Wonderful, or try your hand at transferring your own sketch to a large wall.

About the Project

This exercise will help you become familiar with the functions of and differences between fat and skinny caps. Skinny caps are used for thinner marks for outlines and details, while a fat cap will give a nice, even spray to fill in larger areas. Practice spraying with each cap on a piece of scrap wood or cardboard, then with multiple colors to familiarize yourself with the properties of each cap—and remember, practice makes perfect!

1. Make guide ticks on the wall to mark the size of the piece.
2. Use a skinny cap to sketch the main components and outline.
3. Continue outlining the piece, alternating colors for different shapes. Adjust the primary sketch and fix proportions if needed.

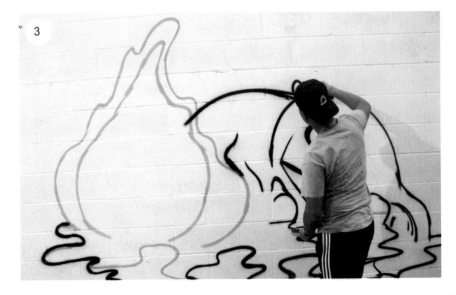

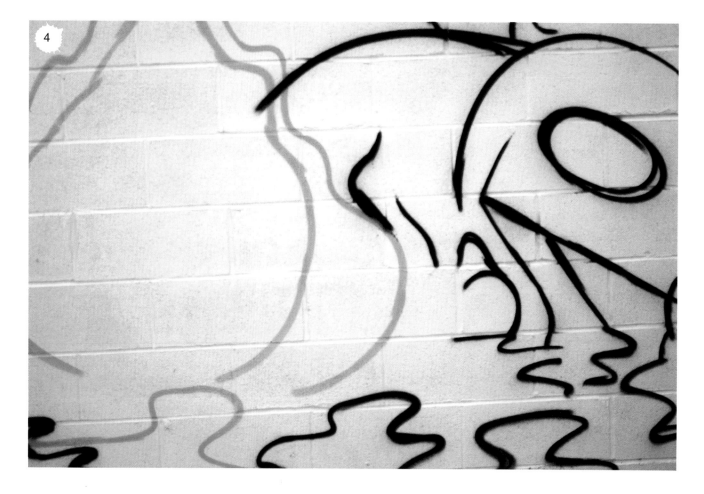

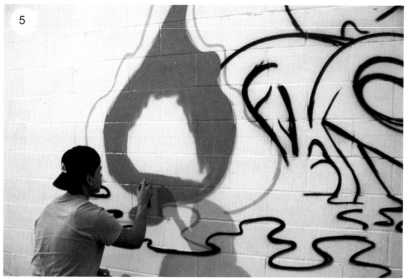

4. Still using the skinny cap, correct any errant outlines.

5. Switch to a fat cap and begin to fill in the outlines, using broad sweeping motions to cover more area. Switch colors and ease up on spray pressure to create dimensionality within each section.

6. Continue to fill using a sweeping motion. Sharpen the image by going back and forth between a fat and a skinny cap to fine-tune detail.

7. Add final details using a skinny cap and white paint, then stand back and enjoy your final piece!

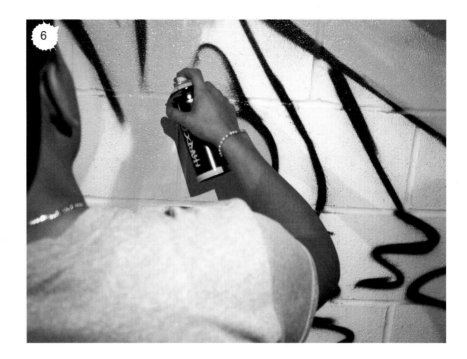

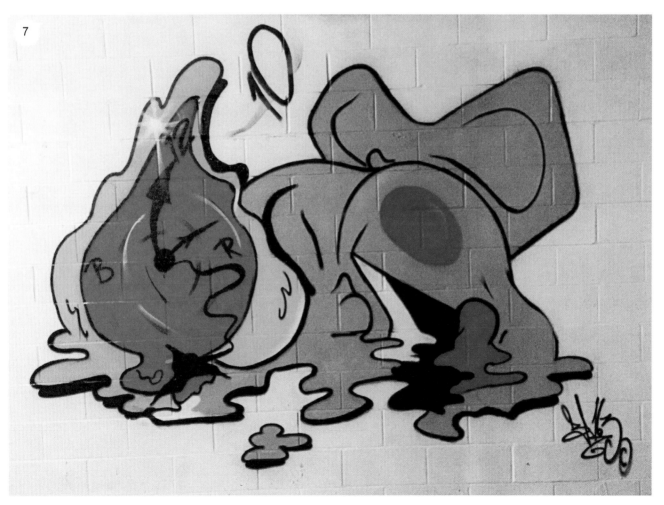

CRASH, AKA JOHN MATOS

A Classic — Bronx, New York

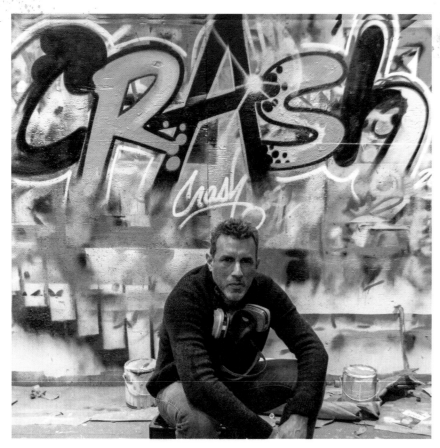

Studio Shot of Crash, Bronx, New York, 2014. Photo © David Gonzalez.

Factbox

- Crash started painting New York City train cars in 1974 at age thirteen.
- The name "Crash" refers to an unfortunate incident in high school when the artist accidentally crashed the school system's network.
- The artist currently runs a Bronx-based gallery, WallWorks NY, along with his daughter, Anna Matos, and friend Robert Kantor; the gallery's purpose is to showcase urban artists.
- Crash has worked with Keith Haring and Jean-Michel Basquiat.
- The artist is known for his iconic style which combines graffiti, Pop Art, and comic book influences.
- He takes a freehand approach with spray paint, using preliminary sketches as his guide.

www.crashone.com

From the Early New York Graffiti Scene

Widely regarded as one of the pioneers of the graffiti art movement in New York City, Crash (aka John Matos), based in the Bronx, remains a relevant and powerful force in the art world today. Although he started painting trains in the 1970s and 1980s, Crash has since traded the subway for commissioned walls and canvases that can be found the world over. His work is known for its colorful blend of styles, from his roots in iconic graffiti to inspiration taken from the Pop Art movement and the comic books of his childhood. Crash's continuing attraction to the immediacy of spray paint has kept him working in the medium for decades, and it has made him a living legend in his own right.

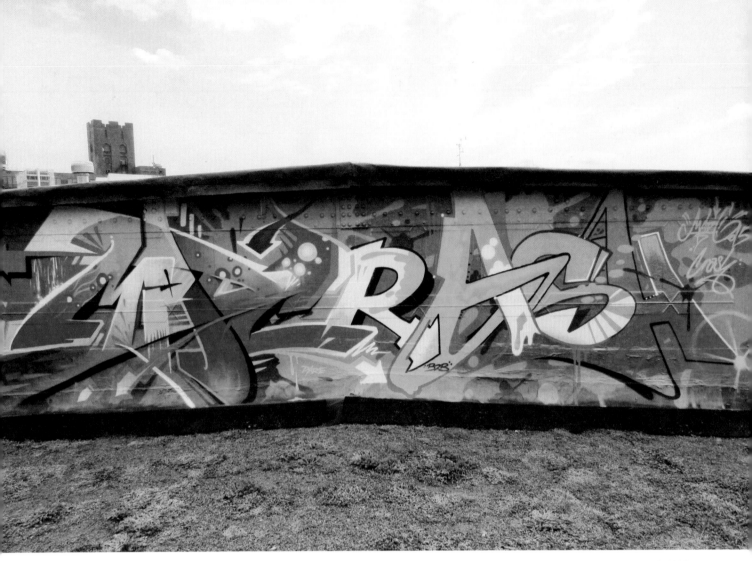

Mural, New York, 2015.

A Pop Influence

To the burgeoning New York graffiti world of the 1970s, spray paint was the answer to making work not only quickly but also with bold and continuous colorways. Crash was introduced to spray paint by watching older kids in his Bronx neighborhood experiment with graffiti. After working in acrylic, oils, and markers as a child and young teen, Crash tried his hand at spray at the behest of his friends, and he never looked back. He was highly influenced by early anime such as *Speed Racer* and *Gigantor*, along with Marvel Comics, and his palette was refined at a young age, when he experienced the works of evolutionary Pop Artist James Rosenquist at New York City museums. Crash integrated these early influences with spray paint, using a freehand style that teeters on the edge of Pop and graffiti. His early works on the street were simplistic, affected by the need to finish large pieces in a short time—before getting caught.

Soon he refined his style and learned to manipulate the effects of the spray. His style today juxtaposes image-driven and written language, often using closely cropped lettering and images that appear to be collaged together. It is an example of outstanding spray can control.

Mural, Wynwood Walls, Miami, Florida, 2015.

From Haring to Basquiat

Crash made the transition from street to gallery in 1980; When he curated the exhibition "Graffiti Art Success for America" at the seminal Bronx gallery Fashion MODA. This exhibition reframed graffiti in the gallery context, kick-starting the decades-long fight to position it among other movements in art history. The exhibition flier said it would "legitimize graffiti artists" and would be "as colorful as walking through a rainbow"—and that it was. Crash, Futura, Lady Pink, Zephyr, Lee, and others spray painted pieces of plywood, which hung like canvases to great acclaim.

The exhibition helped a handful of graffiti artists to become accepted, and subsequently appropriated, by the blue-chip art world—including Crash's friend Keith Haring. This early success led to a project with the Public Art Fund along with Haring and nine other artists, a headlining show with Jean-Michel Basquiat and Keith Haring at Sidney Janis Gallery in 1983, and a mural project again with Haring at the Musée d'art Moderne de la Ville de Paris in 1984.

Although some graffiti writers and artists from his era fell to the wayside over the years, Crash's career thrived, spanning multiple decades, with gallery and museum exhibitions as well as commissioned outdoor walls on view across the globe. His work can be found in the collections of the Museum of Modern Art in New York, the Brooklyn Museum, and the Stedelijk Museum in Amsterdam, among countless others.

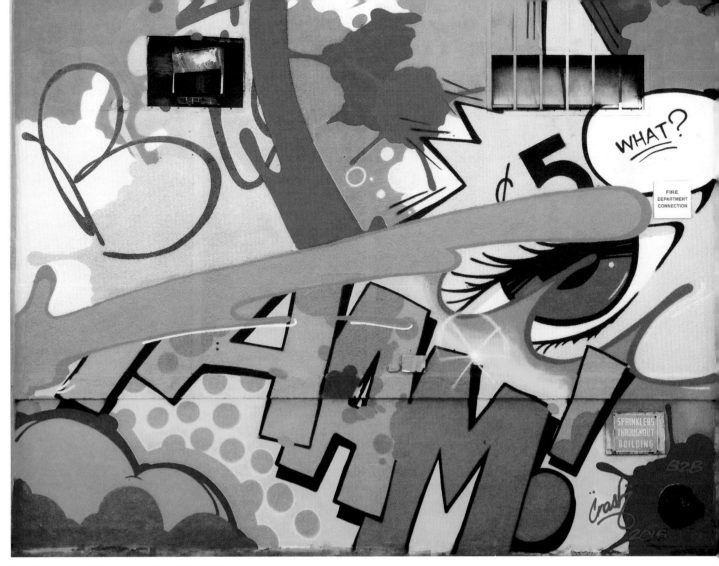

Mural, Long Island City, Queens, New York, 2015.

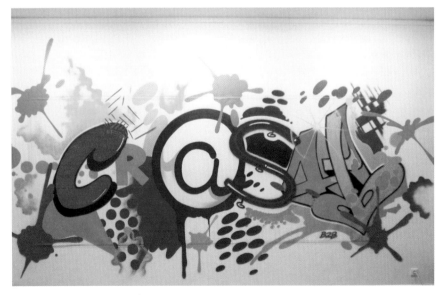

Mural, Villa Tamaris Centre D'art, La Siene Sur Mer, France, 2014. Spray paint on canvas.

"I've seen tags and paintings in the streets going back to the '60s."

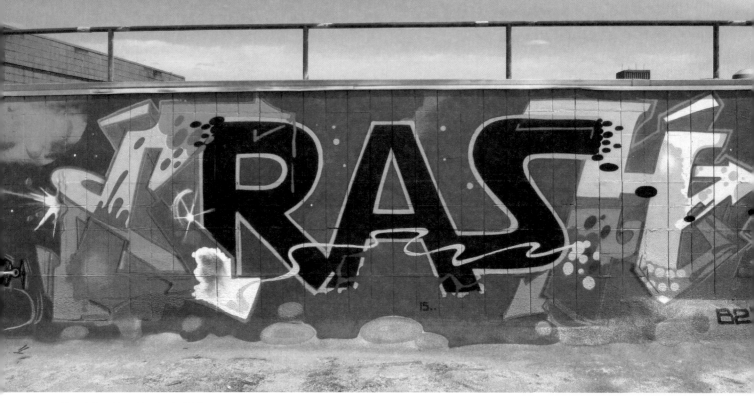

Mural, Brooklyn, New York, 2015.

Crash's success can partially be attributed to his recognizable style capturing the bold and vibrant feeling of early graffiti that gets enthusiasts clamoring for his work. Although Crash's days of painting trains are over, the spontaneity of his work can still be felt in his favored style of spray-painted collaged elements. Today, he works from small reference drawings, transferring his intended images to a large scale by sketching loosely onto walls, then freehand spraying directly. His application of hard-edged lines using careful can control gives his murals his desired collagelike quality—a throwback to his youthful appreciation of James Rosenquist.

"I was very preoccupied with the stability of spray paint—its durability and how it would stand the test of time on canvas," Crash said when asked about spray paint's not-so-archival attributes. "Then I realized that while traveling throughout the years, I've seen tags and paintings in the streets going back to the '60s, and if they can endure forty to fifty years on the streets with all the weather beating on them and they're still around, then I think the paintings will be safe in institutions and homes around the globe."

Today, Crash divides his time among painting in the studio, traveling for commissioned walls, and working at WallWorks NY, a gallery space he opened in the South Bronx with his daughter, Anna Matos, and business partner Robert Kantor. Wallworks NY embodies the egalitarian spirit of graffiti that touched the neighborhood thirty years ago.

The Crown of Heroes, 2014. Spray paint on canvas.

PICHIAVO

ACADEMIC EVOLUTION – Valencia, Spain

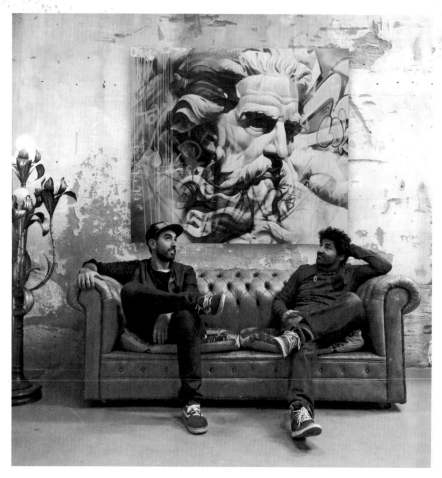

Portrait of the artists, London.

MODERNIZING MYTHOLOGY

Ancient gods, demigods, muses, and heroes live within a realm of spray paint chaos in the enigmatic work of Valencia, Spain–based artists Pichi and Avo, who go by the unified "PichiAvo." An unexpected, yet perfect, mesh of classical Greek and Roman imagery with graffiti, their works of spray paint mastery give the viewer a look into the past through an urban lens. Shirking the ego often prevalent in the graffiti world, PichiAvo create works together as one, united to give their art the center stage, rather than themselves. Their infusion of graffiti into art historical scenes shows the evolution of the genre, and how contemporary artists are incorporating it to create their own dialogue between past and present.

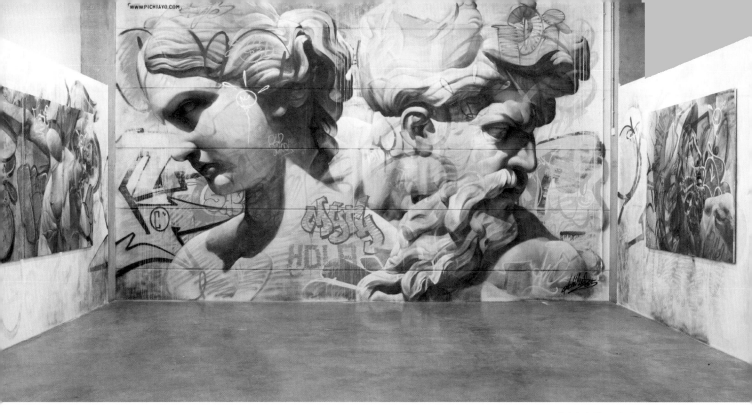

Taking in PichiAvo's art can at first be a delightfully disorienting experience. The combination of historical statues with the modernity of graffiti leaves the viewer with flashes of familiar dystopian films. The massive murals feel like they could be lifted from scenes in *Planet of the Apes* or *1984*, with characters stumbling upon preserved relics that have been vandalized by a roving gang of modern youth. But once the familiarity of those Roman noses and mythological figures has settled in, the colors, markings, and tags of graffiti reveal themselves to be harmonious, enveloping the classical references with purpose and beauty. On a more conceptual note, their work elevates the graffiti writer to a godlike status, validating the graffiti gangs in movies like *The Warriors* and *Escape from New York* with imagery of literal gods and goddesses from mythology replacing the graffiti writer's plight to become "king of the streets."

The mixing of these two worlds—the academia of the Greeks and Romans and the rough democratic nature of the graffiti world—is not an easy feat. But PichiAvo make this duality seem like second nature, just as they do with working together seamlessly to create one vision. Their work resurrects and deconstructs classical art while providing an art history lesson to the graffiti and street art set. Gods and demigods lifted from ancient Greek mythology replace the cartoonlike characters often developed with graffiti, creating a relationship between the genres that also anchors their work in fine art.

Their pieces on the streets evoke the most power, steeped in legend and lore, seen through the contemporary lens of the chaos of the city, as if their muraled walls were an otherworldly portal to view the past, through the haze of graffiti. Using spray paint for graffiti is expected, but for academic art it is a twist that further ties the two genres together.

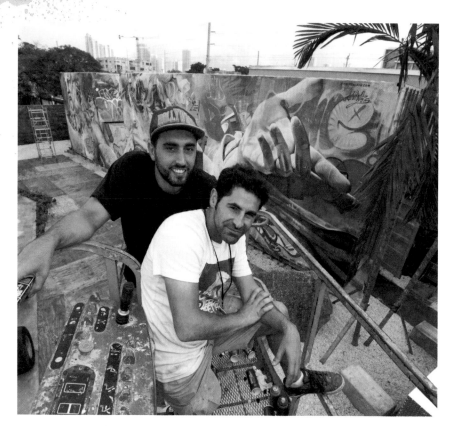

Portrait of the artists, Wynwood Walls, Miami, Florida. Photo © Martha Cooper.

Our works are based on artistic processes, where the evolution of the painting is important and always represents where we come from and what we know, giving more importance to the artwork than the artist; that's why we mix our styles, both working in the same piece, fleeing the artistic egocentrism to give more relevance to the artistic result.

Letting Go of the Ego to Work as One

PichiAvo's process is simultaneous: One artist will paint aggressive graffiti tags while the other works on the soft figures, or vice versa. A high-pressure can (amped up with more butane or methane) creates the heavy markings and colors needed for the graffiti strokes, while a lower pressure can and a soft nozzle create the shaded effects that make the gods and goddesses seem statuesque.

Both artists are classically trained in oils and acrylics. The pair began making work together with spray paint, and as their work evolved to incorporate more classical imagery, it only seemed natural to continue in the medium they had become accustomed to. Spray paint also gave them the freedom to experiment with bigger and bolder projects, trying new ideas without the exorbitant costs that traditional oil painting can incur, dampening creativity.

Throughout the years, they have mastered the use of spray paint through simple trial and error. The smooth motion and forgiving texture of spray allows strokes to be painted again and again until perfection is

The Rapture of Polyxena, 2015.
Spray paint and oil on wood.

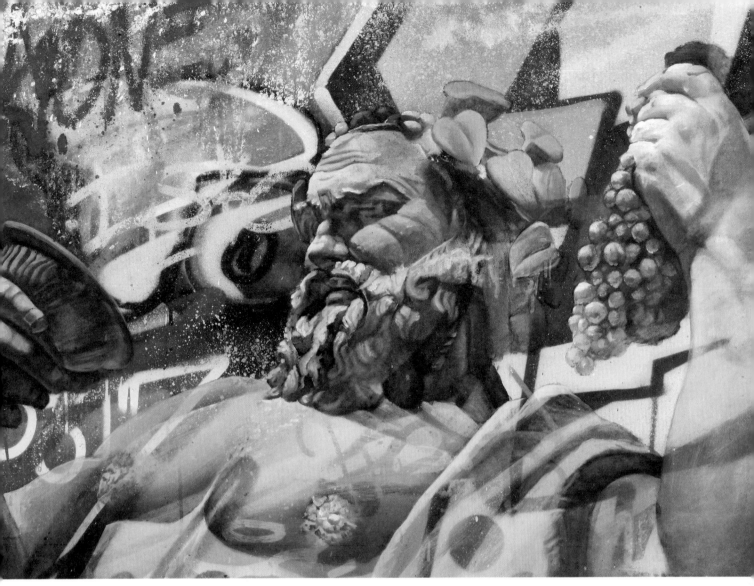

Baco Adulto, 2015. Spray paint and oil on wood.

achieved, encouraging the development of personal technique with little lost. With persistence, PichiAvo have perfected their process, using spray paint as a tool for showing the world their commentary on the relationship among graffiti, sculpture, and architecture.

The unification has not gone unnoticed. Since joining forces, PichiAvo took their home of Valencia, Spain, by storm. And because this is the age of Instagram, the world took notice of their vibrant style. They began landing projects across Europe, as well as scoring a place in the highly coveted Wynwood Walls gardens in Miami, Florida. Their street pieces are paired with equally intricate studio works on canvas and wood that are gobbled up by art collectors. With their success, PichiAvo have created outdoor works and gallery exhibitions all across their native Spain, as well as in Sweden, Germany, Portugal, and Miami, Florida.

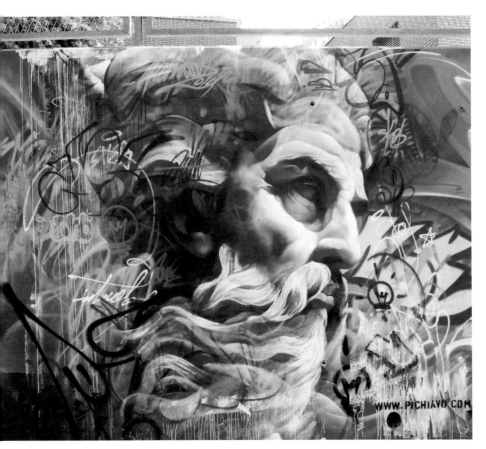

Mislatas Festival, Valenica, Spain, 2014.

Two artists working collaboratively is not unheard of, but it requires them to believe in sacrificing ego for the greater good of art. Individually, the artists were longtime friends but had worked alone on both canvases and murals. They studied fine art in Valencia and Finland, building their own careers, before realizing that their works would become better if they merged their ideas. Two artists harmoniously creating works has a surreal magic that leaves the viewer feeling lucky to experience it.

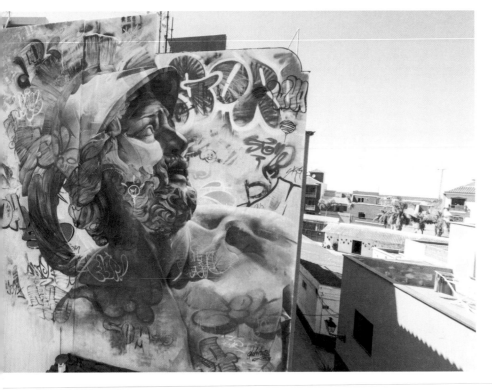

Urban Warrior, Tenerife, 2015.

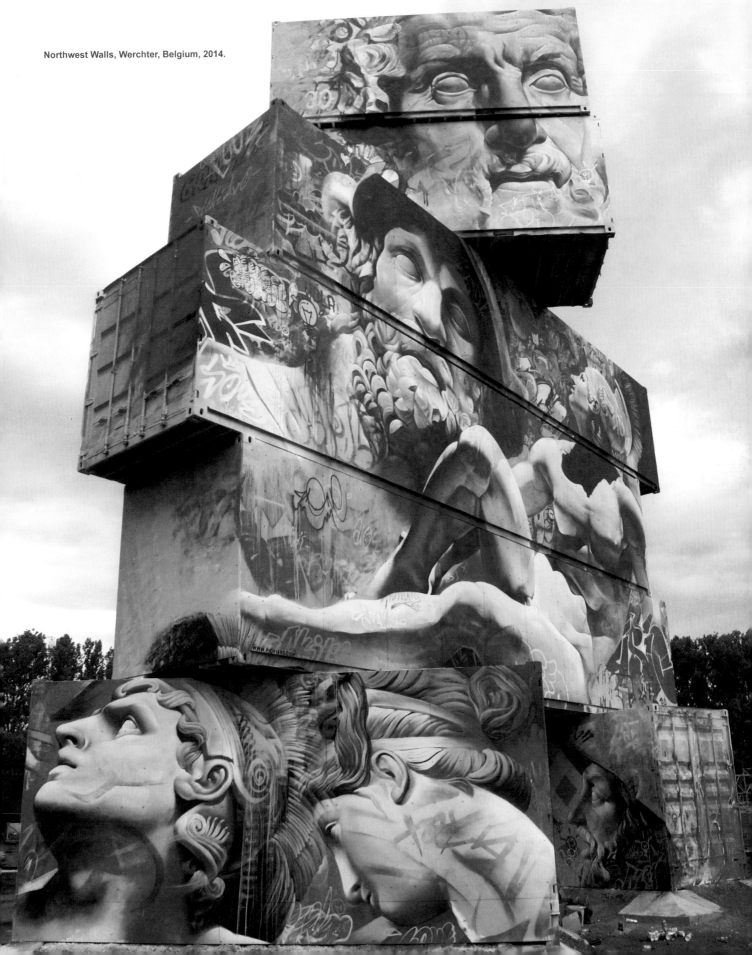

Northwest Walls, Werchter, Belgium, 2014.

BR163

THE NEW CLASS — Bronx, New York

BR163 in the studio, 2015. Photo © Jefte Castillo

FACTBOX

- BR163 was born Branden Rodriguez in the Bronx in 1993.
- The artist is part of the new school of graffiti, inspired by graffiti history in his neighborhood of the Bronx.
- He was introduced to graffiti by the legendary TATS CRU group, of which his father is a member.
- The artist uses a variation of caps to sketch loopy graffiti letters and round characters on walls.
- He attended the Fashion Institute of Technology in New York in 2012.
- BR163's character Mr. Wonderful was the subject of a solo exhibition at WallWorks NY in 2015.

www.instagram.com/br163artwork

Graffiti revolutionized communities throughout the Bronx (and beyond) all through the 1970s and 1980s. For nearly half a century, graffiti has entrenched itself in the fabric of New York's northernmost borough, and it still turns new kids onto tagging and painting with the spray can. BR163 is a member of this new class in the Bronx, picking up the torch of graffiti passed on from generations in his neighborhood. Born (as Branden Rodriguez) in 1993, two decades after graffiti's heyday in his area, BR163 was exposed to the allures of the graffiti world when he was just five years old. Now the young artist is honing his fine art skills learned at college to create a graffiti and gallery career of his own, inspired by the artists he grew up around.

Untitled, 2015. Spray paint on canvas.

Inspired by TATS CRU

TATS CRU is a group of Bronx-based graffiti artists who have become professional muralists, known not only for securing commercial clients but also for having worked extensively with musicians over the past twenty-plus years. As he was growing up, BR163 spent a lot of time around his father and the members of TATS CRU, mastering how to use a spray can in his childhood. This early start gave the artist a leg up on the graffiti world, with the ability to soak up skills, tips, and stories from experienced graffiti artists who banded together with the goal of showing the world that graffiti should be an accepted art form. It also gave him an introduction to the public art realm, with members of TATS CRU including him in their large-scale mural collaborations.

> I was introduced to spray paint by TATS CRU at the age of five when they were painting the memorial wall of Big Pun. I was amazed by how a can of aerosol is able to apply paint onto a wall instead of a typical art medium, such as a brush. It was exciting to see that happen, so I decided to grab a can that was in my basement to give it try.

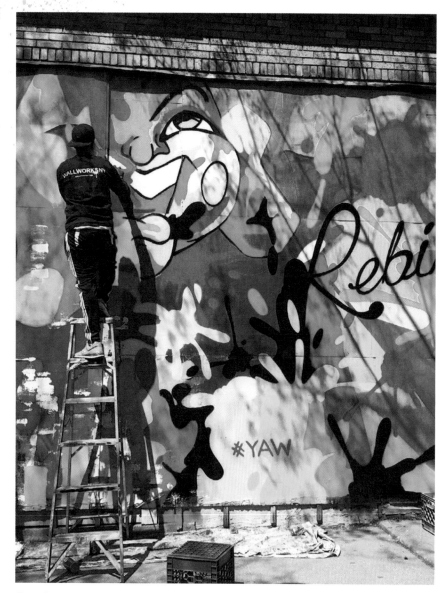

Mural, Bronx, NY, 2015.

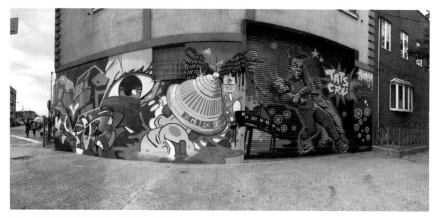

Mural with TATS CRU, New York, 2015

Taking inspiration from his elders, BR163 began exploring typical graffiti, tagging his name and bombing walls around his neighborhood. Because of his lineage, he also had access to mentors such as Crash and Mist, and he gained wisdom through mural collaborations with more experienced artists. The scope of his work expanded after enrolling in the Fashion Institute of Technology to study fine art at eighteen. His spray skills combined with other mediums and techniques, and the artist even ended up teaching the teachers a thing or two.

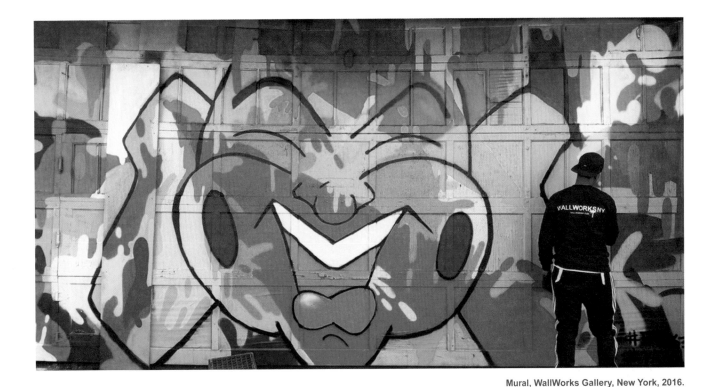

Mural, WallWorks Gallery, New York, 2016.

Developing Mr. Wonderful

Under the influence of his technical classes in college, BR163's graffiti soon evolved from painting words to painting characters. Mr. Wonderful, a smiling, apple-cheeked character, began making an appearance alongside BR163's colorful markings and lettering. The Buddha-inspired character has been painted with various blocking and colorways, but his consistency comes from the goofy, gaping grin and a continuously flat-dimension surface. It also often appears within BR163's murals and collaborations, as well as on canvases in the studio. In 2015, his mentor Crash, and Crash's daughter Anna Matos, gave BR163 an incredible opportunity to showcase Mr. Wonderful in the artist's very first solo exhibition at their Wall-Works NY gallery in the South Bronx. The exhibition was accompanied by a large-scale site-specific spray-painted mural on the gallery's facade, tying in BR163'early years in graffiti with his fine art studies at FIT.

Carrying on the Bronx Tradition

Steeped in the Bronx graffiti world, BR163 approaches the genre as if it is his own. Despite being younger than most of the graffiti artists he works with, he approaches the wall with the professionalism and enthusiasm of a seasoned artist. Many artists his age are intrigued by new media, but BR163 has decided to carry on the legacy of the genre he was raised around.

New to the scene, BR163 has painted several mural collaborations in Brooklyn through the Bushwick Collective, in the Bronx with TATS CRU, and with WallWorks NY.

2

A WORLD
OF MURALS

Mural by BR163, Bronx, New York, 2015.

With the rise of graffiti and street art in popular culture, spray paint has taken center stage. Once a delinquent act, spray-painted murals have become cultural currency, drawing attention to blips on the map and the makers behind the can. Mural programs and festivals have popped up across the globe, changing the face of neighborhoods and attracting art tourists to these new, makeshift outdoor museums.

Mural festivals geared toward street art and graffiti have gained traction in recent years as the popularity of these genres became validated with gallery and museum shows in the mid-2000s. In addition to the growing fandom of the genre, the diminutive overhead that painting murals requires makes it attractive for organizations and artists to put their work on the streets. With murals, organizers can beautify a neighborhood for basically the cost of some cans of spray paint (and artist fees, of course), rather than taking on the production costs and bureaucratic red tape involved in large-scale public sculpture and landscaping. Enlisting a few artists to create murals on the sides of buildings not only gives locals pride in their surroundings but also attracts street art tourists, who help invigorate local economies. Communities across the world began (and continue to) invite international artists to come to their neighborhoods to create outdoor murals, some intended to be permanent. From the tiny island of Djerba in Tunisia to the inner city of Baltimore, veritable outdoor museums of spray-painted art are now part of the landscape, inviting viewers to appreciate art through a democratic lens rather than in a museum or gallery.

But the cultural cachet attached to these spawning mural festivals also has a downside. Struggling neighborhoods have brought in outdoor murals as a means of beautification, only to see their efforts work against them. Residents of areas like the Wynwood section of Miami, Bushwick in Brooklyn, and more recently Detroit are finding themselves priced out of their own neighborhoods. Real estate developers, attracted to the buzz that art and artists bring to an area, pounce on the newly adorned buildings, and neighborhood beautification becomes dreaded gentrification. There is also the issue of locals not liking the artists chosen to create semipermanent pieces in their neighborhoods. Well-organized mural programs avoid this problem by making sure they get the community involved in and excited by the art selection process.

Despite their flaws, mural programs and festivals have exploded in popularity, and have shown that an art medium can change the world. The bevy of outdoor art engages and attracts visitors in an approachable and accessible way that galleries and traditional museums do not.

Spray paint plays a large part in these mural projects. In addition to artists using wheat paste and brush, a majority of the artists rely on spray, using various techniques. Large-scale stencil pieces, traced projections, and totally freehanded works made from small reference drawings are some of the ways artists make big impressions on big walls.

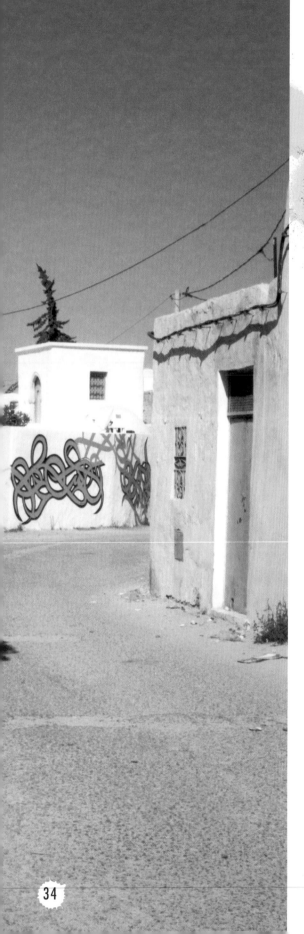

DJERBAHOOD-ER-RIADH

Djerba, Tunisia

www.djerbahood.com

In the summers of 2014 and 2015, the village of Er-Riadh on the island of Djerba in Tunisia offered its crumbling historic walls to 150 artists from more than thirty countries around the world. The project was the brainchild of Tunisian Mehdi Ben Cheikh, who runs Galerie Itinerrance in Paris. Cheikh worked with the local government and community, essentially asking community members to offer up walls of their homes for artists to paint. Djerbahood differs from other mural projects in that it juxtaposes contemporary art with the rich history of one of Tunisia's oldest settlements, where Jewish communities have flourished alongside Islamic rule for 2,500 years. The island of Djerba first thrived during the Roman and Byzantine periods, and its fertile land and beautiful beaches have kept the island a popular destination for tourists in recent years. Er-Riadh itself is a less-traveled village, known for the ancient El Ghriba Synagogue (Africa's oldest) and its traditional sandstone architecture, much of which has been inhabited for centuries.

The dialogue between tradition and modernity is felt not only in conceptual intention but also in the otherworldly imagery in the painted town. The Djerbahood project was inspired by the area's deep history; it's a place where Jews, Christians, and Muslims have lived together for 2,000 years, a fitting venue for the interaction of vivid art and ancient architecture.

The community weighed in and selected art and artists for their walls. The selected artists created pieces that respect the history, religious beliefs, and architecture of the community. The project is expected to remain permanently on Er-Riadh's walls, weaving itself into the fabric of the village's history with permanent works by artists such as Swoon, Logan Hicks, C215, El Seed, and ROA.

El Seed, Djerbahood Project, 2014. Photo © Logan Hicks.

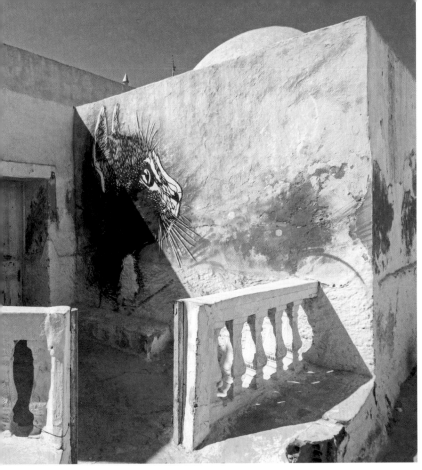

C215, Djerbahood Project, 2014. Photo © Logan Hicks.

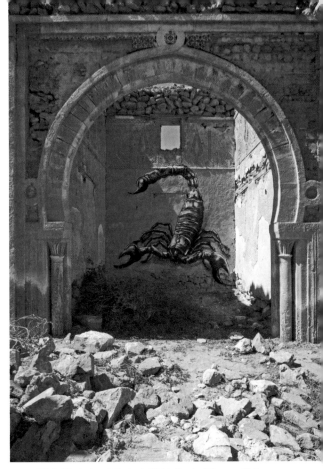

ROA, Djerbahood Project, 2014. Photo © Logan Hicks.

ROA, Djerbahood Project, 2014. Photo © Logan Hicks.

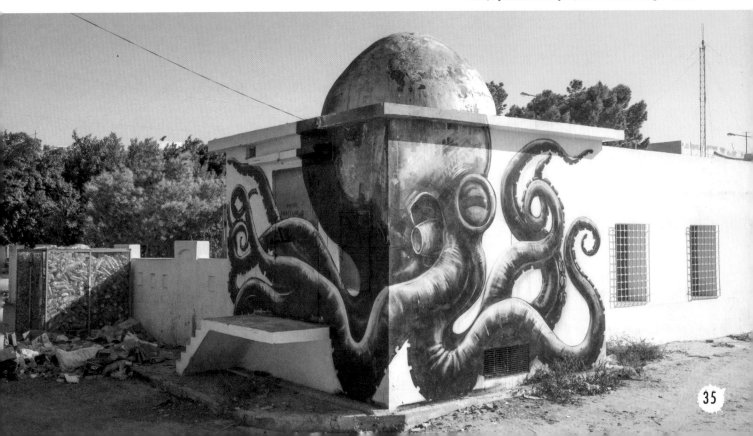

NUART FESTIVAL

Stavanger, Norway

www.nuartfestival.no

Stavanger, Norway, is an idyllic city of fjords and endless waterfronts, dotted with structures dating from the Iron Age, centuries-old churches, eighteenth-century peaked wooden houses, and modern Nordic design. It is also home to one of the first public art festivals to have a street-art edge—Nuart, which has come to be known as the world's leading street art festival. Founded by Martyn Reed in 2001, the Nuart Festival has asked international artists to interact with Stavanger's cityscape, both inside and out, and to create reactionary work that pushes the ideas of what art can be.

With so many mural festivals today inviting artists to paint on sanctioned outdoor walls, Nuart has proven itself a conceptual pioneer, pushing artists to do more than just paint on an oversized brick canvas. As Reed has said, the festival challenges both artists and viewers, first by presenting art outside of traditional venues by interacting with the landscape of Stavanger itself (incorporated into industrial landscapes, wrapped around buildings, lain across vacant lots, or extending beyond the skylines of crumbling historic facades), and then by holding an educational and inquisitive program of panel discussions, installations in galleries, workshops, and events across the whole of Stavanger.

Formed before the saturation and uber-popularity of the street art genre, Nuart has had the time to develop its own curatorial and conceptual vision, free of the media hype or need to cash in on the street art bandwagon. They have continually invited both big names and emerging artists to participate each September.

Today, the festival is looked at as the world's leading culmination of street art, but locals in Stavanger see the pieces around their neighborhoods as simply art.

Strøk, Nuart Festival, Stavanger, Norway. Photo © Ian Cox, www.wallkandy.net.

Aakash Nihalani, Nuart Festival, Stavanger, Norway, 2014.
Photo © Ian Cox, www.wallkandy.net.

M-City, Nuart Festival, Stavanger, Norway, 2010.
Photo © Ian Cox, www.wallkandy.net.

Icy & Sot, Nuart Festival, Stavanger, Norway, 2014. Photo © Ian Cox, www.wallkandy.net.

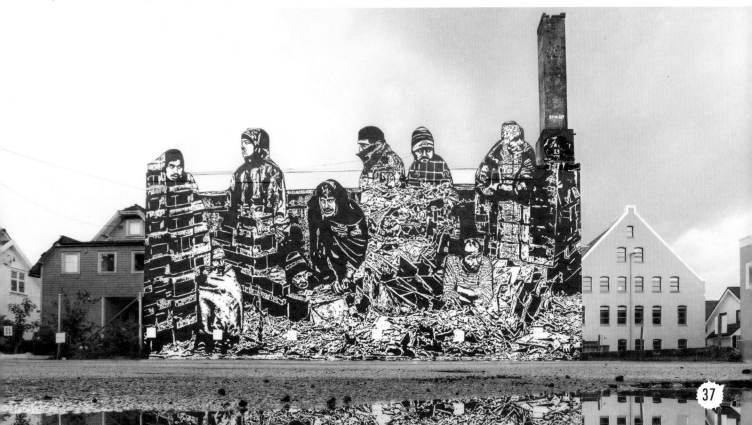

The People
Upstairs Are
Ⓒⓡⓐⓩⓨ

:01

THE UNDERBELLY PROJECT

New York, New York

www.theunderbellyproject.com

While current mural festivals around the world hope to gain as many visitors as possible, the Underbelly Project, which took place in New York City from 2010 to 2011, was meant for an audience of none. Rather than adorning neighborhoods-in-transition or tourist-heavy areas, the street art project took place in the depths of the New York City subway system. Over the course of eighteen months, 103 international artists were led in total darkness down active subway tracks and up ladders by the light of headlamps to an abandoned half-finished subway station by the Underbelly founders, two New York artists who go by the pseudonyms Workhorse and PAC.

The curators have concealed their identities and involvement with the Underbelly Project for legal protection—even continuing to shirk their actual names when recognition was paid. A *New York Times* article about them, a curated gallery show during Art Basel Miami, and their own coffee table book, published by Rizzoli, all address the pair by their pseudonyms. Despite their anonymity, the book and exhibition released images of the works painted in the thick blackness of the MTA underground, capturing never-to-be-experienced masterpieces by leading artists like Saber, Faile, Swoon, Tristan Eaton, The London Police, and of course, the curators themselves.

The idea for the Underbelly Project was hatched when PAC brought Workhorse, a fellow urban explorer, to the underground space. Despite how difficult it is to get there, and the fact that the public could never see it in person, the pair found a certain magic in a clandestine street art museum that could be discovered a hundred years later—that is, if underground moisture or vandals don't get to it first.

True, the Underbelly Project can only be experienced through photographs and unreleased video, but the idea of an immersive street art project concealed beneath a city holds a science fiction narrative begging to be discovered.

Joe Iurato, The Underbelly Project, 2010.

The Underbelly Project, 2010.

WK Interact, The Underbelly Project, 2010.

The Underbelly Project, 2010.

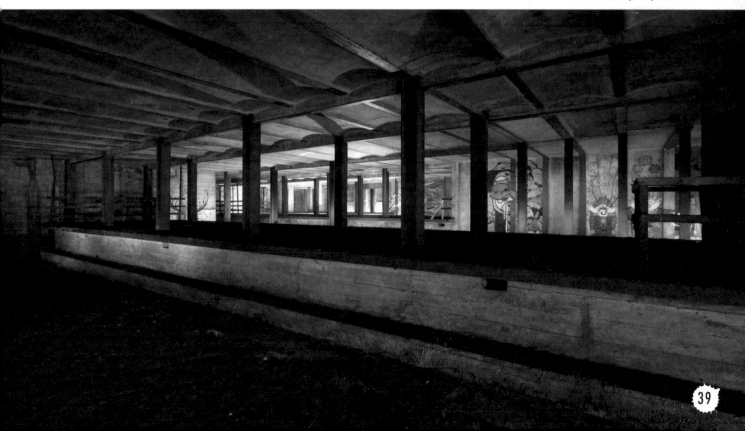

WYNWOOD WALLS

Miami, Florida

www.thewynwoodwalls.com

Miami's Wynwood neighborhood has undergone drastic changes since 2009, when the late Tony Goldman created Wynwood Walls as a way to increase foot traffic in the area, which was already speckled with graffiti and street art. The area had previously attracted organized murals on a smaller scale through Primary Flight, which began inviting artists to paint the primarily industrial buildings in 2007. Under Goldman, an avid art lover and real estate developer, the art of the area was expanded, with a sanctioned central and legal place for selected artists to paint. The Wynwood Walls have expanded to become the focus of the neighborhood during the annual Art Basel Miami, situated around a gated public garden that has grown to include a restaurant, galleries, and a small retail store specializing in books and works by featured artists, as well as Wynwood Doors, which features emerging and less established artists.

The rapid expansion of street art murals in the Wynwood neighborhood has been met with much criticism, as the primarily Puerto Rican immigrants who began settling the neighborhood in the 1950s have found themselves priced out now that artists, designers, and tourists have flocked to the neighborhood to view the hundreds of murals that have redefined the look of the area.

Unlike the murals that have quickly populated the surrounding streets, the Wynwood Walls are protected from vandalism, closing to the public at night and under the watch of hired security guards. Now under the management of the late Tony's company Goldman Properties (which is headed by Tony's daughter Jessica), the Wynwood Walls serve as a top-notch outdoor museum of respected international artists, as well as a center for community and private events. The massive murals remain for several years, accompanied by museum-style wall labels, before the exhibition rotates. The walls were expanded to twice their size in December of 2015, and currently contain pieces by artists featured in this book, including PichiAvo, Crash, Logan Hicks, and Hueman.

Wynwood Walls Garden. Photo © Martha Cooper.

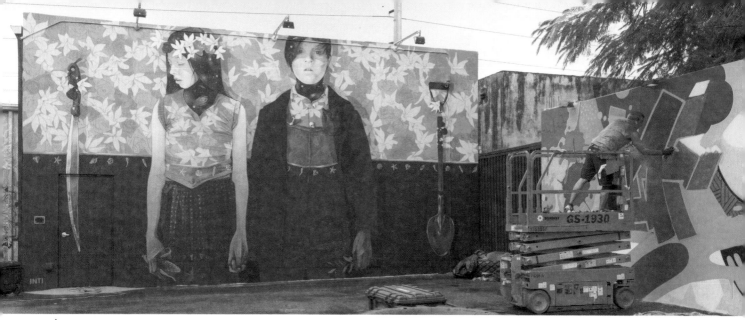

▲ Murals by INTI (left) and Crash (right), Wynwood Walls, 2015. Photo © Martha Cooper.

▼ Mural by CASE, Wynwood Walls, 2015. Photo © Martha Cooper.

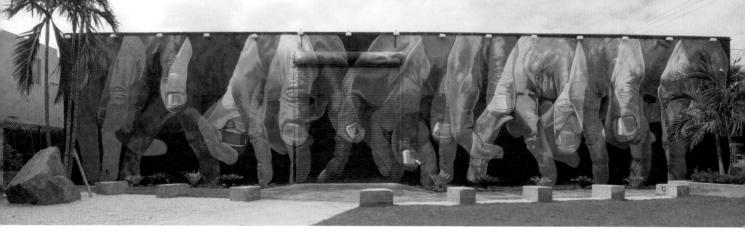

▼ Mural by PichiAvo, Wynwood Walls, 2015. Photo © Martha Cooper.

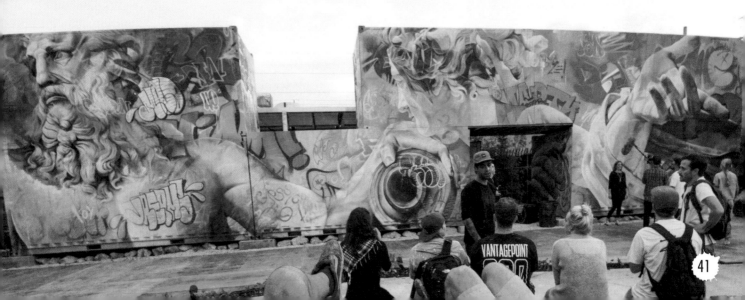

WALL\
THERAPY

Rochester, New York

www.wall-therapy.com

Cities in western New York State that found architectural identity during the peak of American industrialism were later left with a landscape of disused brick factories, processing plants, and gray concrete walls that reveal the effects of the region's signature winter weather. This industrial tableau became a coveted canvas for artists to enliven their surroundings and inspire their communities, a principal belief behind Rochester's WALL\THERAPY, whose first inception was in 2011. The weeklong festival was founded by Dr. Ian Wilson, who applied his principles as a health care provider to healing his community, first selecting eleven street artists to act as "therapists" to "rehabilitate" the city through the healing properties of boldly colorful art. Hosted in the original home of the Kodak company, WALL\THERAPY brings an updated meaning to Rochester's nickname of the Image City.

Each year, WALL\THERAPY not only invites a fleet of international artists to create new work, but Wilson also imparts a curatorial theme, such as surrealism, the human form, or an homage to early graffiti writers in the 1970s. Rochester, a smaller city with extensive working-class neighborhoods, has embraced the program, using WALL\THERAPY as a jumping-off point for community festivals, and accepting it to the point that tours of the murals can now be found in the curriculum of the local public schools. The therapy comes not only in the form of artists as therapists, but also literally, as selected walls are repaired, rehabilitated, and resurfaced to strengthen existing architecture and a smooth canvas for artists.

Wilson has also taken the idea of healing through art to the next level, by launching a sister program called IMPACT! (IMProving Access to Care by Teleradiology). Through philanthropy, IMPACT! installs diagnostic imaging sites in developing countries. The program links Wilson's two passions: the healing property of art and health-focused philanthropy. WALL\THERAPY has recently expanded to include an accompanying gallery exhibition. Throughout Rochester, 115 murals by seventy-five artists can be found.

Jarus, WALL\THERAPY Murals, 2014. Photo © Mark Def.

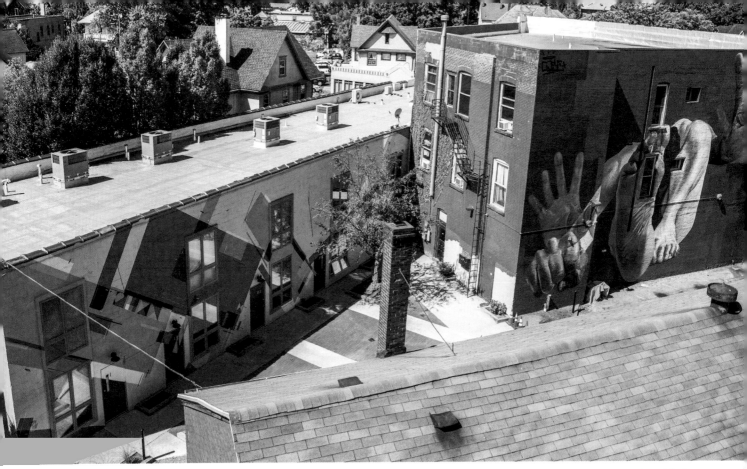

CASE, Monci, Bile, WALL\THERAPY Murals, 2015. Photo © Mark Def.

Addison Karl, WALL\THERAPY Murals, 2015. Photo © Mark Def.

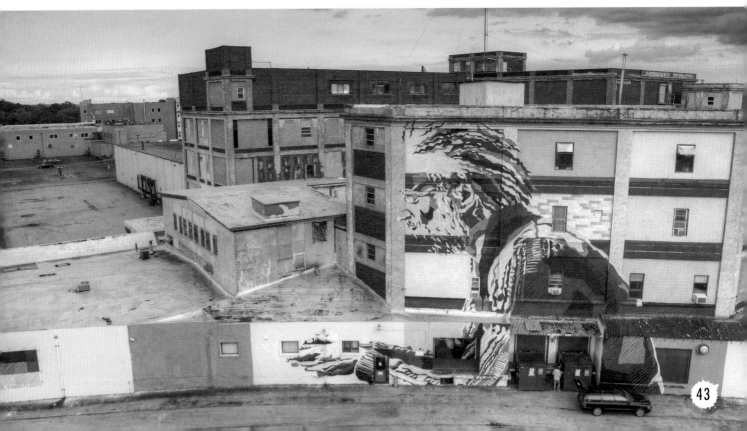

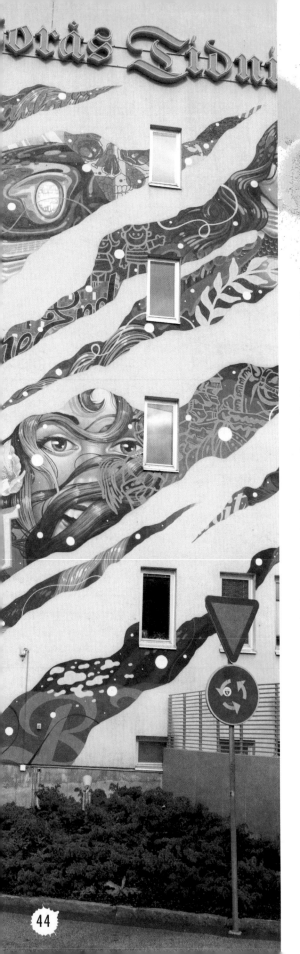

NO LIMIT

Borås, Sweden

www.nolimitboras.com

The small city of Borås is about an hour's train ride inland from Gothenburg, and is situated around the picturesque Viskan River; which winds its way through downtown. Despite its small size, Borås has a history of opening its doors to art of all genres, including street art.

When the festival's curator, artist Shai Dahan, arrived in the small city with his Swedish wife in 2010, he noticed a lack of the street art he had come to love in New York, so he began wheat pasting his own Dala horses around town and in Gothenburg. Gaining attention in a local newspaper, Dahan was quoted saying he hoped a street art festival would come to the area. A week after the interview was published, the Borås Modern Art Museum contacted Dahan, and the festival was born.

Since 2014, Dahan has been careful to include not only mural artists but also nontraditional sculptors, painters, and even a chalk artist. With these diverse artists, the festival extends beyond the walls outdoors and into local restaurants, the town square, and parks. This approach has made No Limit Borås a more well-rounded arts festival that appeals to all ages within the close-knit Swedish community. Throughout the weeklong festival, much of the local population turns out to attend one of the many tours or Q&As with the artists, eager to learn about rather than criticize the new works populating their neighborhoods.

In turn, the artists' experience is akin to summer camp or an artist's residency. Meals are taken together in one of two supporting restaurants, community volunteers drop off hot coffee and cookies for the artists as they work each day, and artists are given artistic freedom. While many festivals require artists to submit sketches of their planned murals, No Limit Borås places an unheard-of trust on their chosen artists, allowing each to execute his or her vision as intended.

No Limit Borås hopes that their camaraderie with street art will inspire other small Swedish towns and cities to welcome it into their communities, rather than fight it.

Tristan Eaton, No Limit Boras, Boras Sweden, 2015. Photo © Anders Kihl.

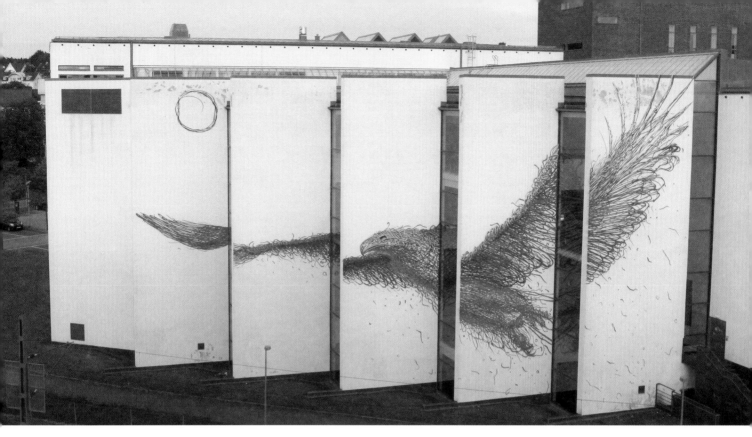

DALeast, No Limit Boras, Boras Sweden, 2015. Photo © Anders Kihl.

Robert Proch, No Limit Boras, Boras Sweden, 2015. Photo © Anders Kihl.

Dulk, No Limit Boras, Boras Sweden, 2015. Photo © Anders Kihl.

3

PUSHING STENCILS TO THEIR LIMITS

Siren of the Sea by Logan Hicks, 2014.
Spray paint on canvas.

Like spray paint, stencils are widely used in industrial, commercial, and residential settings, making their relationship a perfect match. With a stencil template, an image or letters can be reproduced again and again, quickly and often cheaply. Made from paper, cardboard, plastic sheets, oil board, metals, or wood, stencils allow images to be repainted with a similar quality again and again, as long as the materials can withstand coats and coats of spray paint. Although this easy replication allows street artists to get their messages up easily, the simplicity of stencils also challenges them to create more sophisticated techniques that result in detailed, sometimes photorealistic imagery.

Stenciling began as the answer to a basic, utilitarian need—making easy replication and labeling for identifying equipment, dangers in construction zones, industrial markings, and the like for the military, local highway departments, construction companies, and other commercial users. They also found their way into the decorative arts and DIY projects, making for easy and inexpensive ways to transfer ornate patterns or images onto virtually any flat surface.

Stencils are made by cutting away negative space by hand or mechanically, leaving stencil "islands" to keep a piece of material together. The cut material is then placed over a surface (concrete, wood, canvas) and sprayed with color. The stencil is then removed, leaving the positive of the cutout. More durable stencils, made from plastics, metals, or oil board, can be saved and used many times, but many DIY stencils—made from cardboard or paper—have a short shelf life. The image quality declines as paint builds up on the stencil.

Early artists used this technique at its most basic, cutting away images that required only one layer or color of spray, often for making quick pieces on the streets. Political artists and the anarcho-punk band Crass used stencils to spread their messages of antiwar, feminism, and anti-consumerism, making the style recognizable around the London Underground; it was quickly picked up by other artists hoping to get their messages and imagery up. In the early 2000s, the Internet forum Stencil Revolution inspired a new wave of stencil artists who could trade ideas and techniques and work online.

With one-layer stencils on the streets becoming common, some artists began playing with multiple layers to create more detailed and colorful pieces for their studio work. These multilayered pieces required characteristics that were not typical of stencils—time, precision, and a thorough understanding of color theory—much like the seriograph process, but done meticulously by hand. Now, holding a stencil steady was not the only formula for a successful piece. These artists also needed to understand the placement and coloring of each layer in completion before the first layer was even sprayed. Although two layers is considered intricate, some artists push stencils even further, carefully aligning sometimes twenty or more stencils to create spray-painted images that are so photorealistic it's hard to believe they were made using stencils.

Artist Logan Hicks manipulates stencils into replicating a seriograph process, producing photorealistic imagery of vast architectural landscapes and detailed figures. Joe Iurato's stenciled woodcuts are juxtaposed with the environment, creating playful narratives for viewers to discover. Nick Walker is the classic stencil artist, known for his Vandal character that hits the streets around the globe with a playful jab between art and vandalism.

DIY

Painting A Stenciled Landscape with Logan Hicks

Whether stencils are cut by hand, store bought, or machine cut, they allow artists to not only create multiples easily but also to explore the effectiveness of color. For this exercise, artist Logan Hicks designed his three layers of stencils digitally, vectorizing his original photographs, then sent them to a laser cutter to properly render his stark architectural landscapes for precise and miniscule details that make his pieces pop. Hicks uses stencils to allow the power of color to convey his voice and vision.

About the Artist

Logan Hicks is a Brooklyn-based stencil artist known for creating photorealistic scenes with multiple layers. His advanced understanding of color and precision has gained him worldwide recognition within the stencil and urban art worlds.

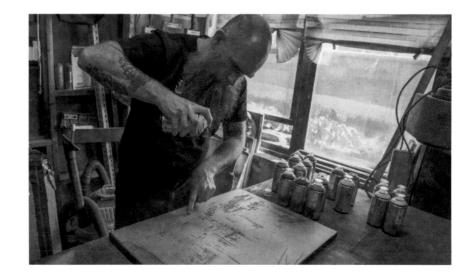

About the Project

Before starting, be sure to find a well-ventilated area to spray in. To make this image, Hicks uses three stencil layers: one to provide the foundation and two for highlighting details. This photorealistic approach is more sophisticated than one-layer stencils that require just one color. In this project, Hicks uses multiple colors in each stencil layer to achieve dimensionality and artistic effect.

For projects with multiple layers, use stencils that have some weight to them. Using Mylar or thin printer paper will result in the stencil moving once the force of the aerosol hits it. For each layer, apply multiple thin layers of paint (allowing each layer to dry) as needed to achieve opacity, instead of applying one thick layer of paint. One thick layer of paint will cause the paint to bleed under the stencil and will blur the detail. Patience, practice, and precision will soon yield perfect multilayered stenciled works.

1. Work on a flat surface so that the stencil stays flat against your canvas. Clear your work area so that nothing is within 2 feet (61 cm) of it. Choose your colors and lay them out.

2. Place your first layer onto the canvas or panel, making sure there is no direct wind, as it will affect how the paint lays on the canvas.

3. Choose a nozzle that sprays with low to medium pressure. Begin to lightly spray your first layer, alternating colors if you wish to add different gradations.

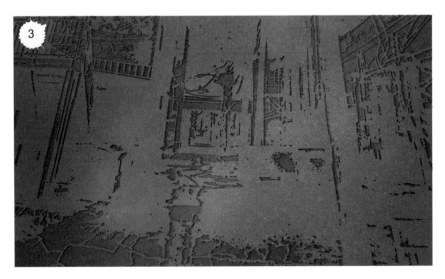

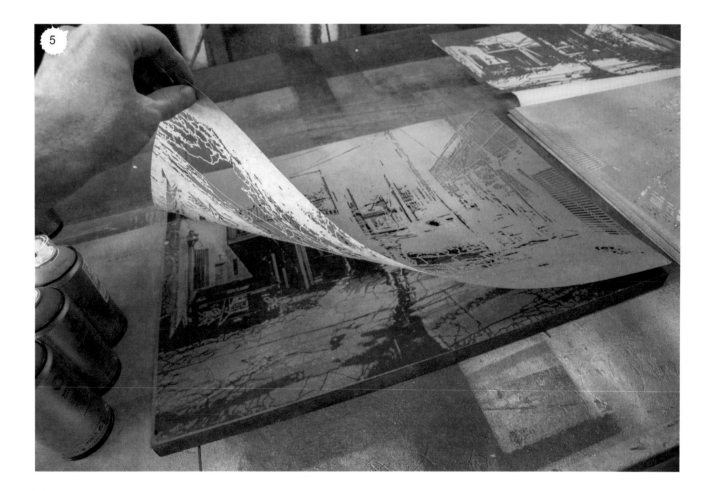

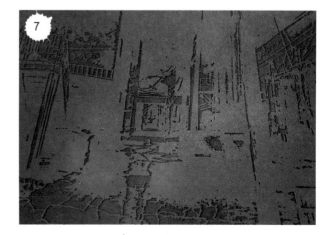

4. Start spraying, sweeping from one side to the other with narrow overlaps, and spraying past the edge of the paper each time. Spray each layer with steady and consistent strokes, holding the can 4 to 8 inches (10 to 20 cm) away from the canvas, and make sure you maintain the same distance while spraying. Allow your spray stream to be as perpendicular to the canvas as possible.

5. Allow the paint layer to dry for about 15 seconds before moving the stencil. Once dry, carefully pull the stencil off, raising it directly up so that it doesn't rub against the surface of the painting.

6. Once the stencil is pulled off, allow the paint to dry for another 2 minutes before registering the next stencil on top of it.

7. Place the next stencil onto the canvas or panel and make sure it is properly lined up. Your stencils should have fewer details (negative spaces to spray) as you move through them. Use a medium highlight color for the second stencil, like a deep yellow. Repeat the drying process for this layer as above.

8. Continue this process until all layers have been sprayed. This final layer should have the image's minute details, so use a pale color or white to bring out the highlights.

9. Once you finish your stencil, allow the canvas to dry overnight before wrapping it up. When possible, allow the canvas to bake in direct sunlight to properly dry.

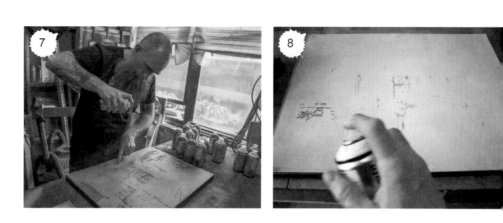

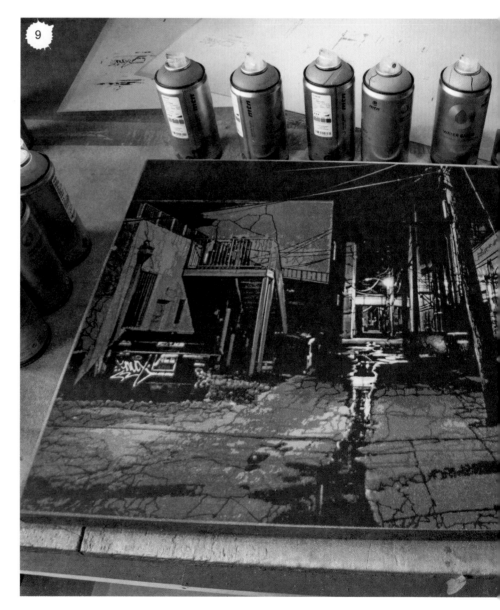

LOGAN HICKS

FROM STENCILS TO PHOTOREALISM – Brooklyn, New York

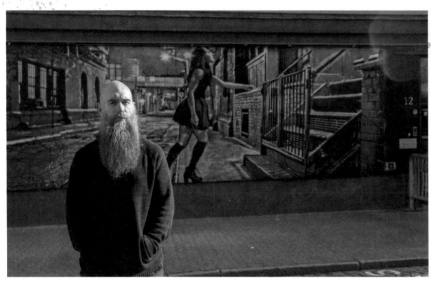

The artist and his mural, Borås, Sweden, 2015.

Known for his elaborate multilayered artworks depicting desolate urban landscapes, Logan Hicks has become one of the most revered stencil artists in the world. Throughout the years, the Brooklyn-based artist has mastered the stencil, at times using up to twenty layers to create photorealistic scenes, often on a grandiose scale. Working both in the studio and outdoors, Hicks has learned to manipulate his technique to create enigmatic pieces that obscure perceptions of the stenciling process.

ROOTS IN SCREEN PRINTING

Before exploring stencil art, Hicks started as a screen printer to artists who have made names for themselves in their own right. After studying fine art at the Maryland Institute College of Art, he opened a screen-printing shop in Baltimore in the mid-1990s, making a living by printing works for Shepard Fairey, Dave Kinsey, and Eric Haze. Despite being an artist himself, Hicks found the confining exactitude and precision of screen printing left little room for his own self-expression. Moving across the country to California in 1999 gave Hicks time to look for a more forgiving medium to work in as he searched for a location to reestablish his screen-printing business. He then began to hand cut stencils with an X-Acto knife and experiment with making his own work. Taking inspiration from the layering process of screen printing, Hicks combined his experience with cut stencils to form his signature stencil style.

FACTBOX

- Logan Hicks is based in Brooklyn, New York, and was educated at the Maryland Institute College of Art.
- He uses original photographs to make multilayered stencil murals and paintings.
- Hicks has used up to twenty layers to create one painting.
- His hyper-real architectural scenes are often perceived as actual photographs.
- Some of his murals can be found all over the world, most recently in Miami's Wynwood Walls and New York's Bowery Wall, which is 70 feet (21.3 m) long.
- Hicks started his career doing screen-printing work for Shepard Fairey, Eric Haze, and Mike Giant in the 1990s.

www.LoganHicks.com

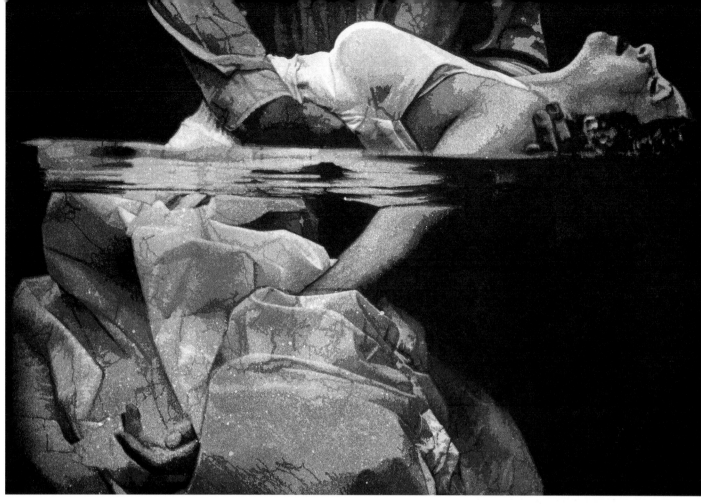

Deep Sleep, 2014. Spray paint on canvas.

Her Hands Said What Her Lips Could Not,
2014. Spray paint on canvas.

At first, Hicks applied screen-printing characteristics to his stencil work, using bold, graphic imagery that usually involved around four or five stencil layers, divided into highlight, middle tone, dark tone, and black. Each layer was hand cut from ordinary paper, then layered by painting the lightest colored layer first and the darkest color last in order to create hard lines. Putting the darkest layer on top made this process somewhat forgiving if the stencils were not lined up perfectly.

Although effective, this process had its limits. First, paper stencils are flimsy and susceptible to underspray and overspray—the bleeding of one painted layer onto the next—due to the thin quality of paper. This method also could only produce solid colors, creating graphic imagery that evoked printmaking.

Wanting to make imagery that was more painterly, Hicks made the switch from paper stencils to oil board, a durable material used to replicate industrial markings. Unlike paper, oil board can hold paint without buckling and stays flat after paint buildup from using it multiple times.

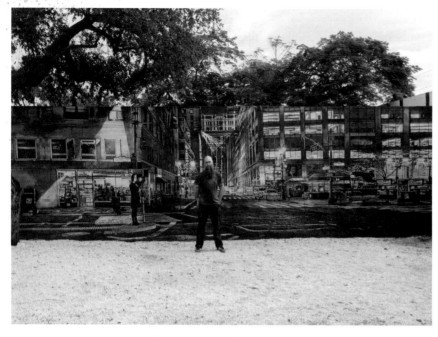

Lemon Vodka and Churros, **Wynwood Walls, Miami, Florida 2015.**

MAKING COLOR A FOCUS

Using oil board changed Hicks from a print maker into a painter. With his new durable stencils and machine-assisted production, no longer bound by the technical limitations of the medium, he began looking at painting in a whole new way and to revising his approach. He reversed his process of painting light to dark, starting with blacks and deep hues as a base. Each layer now faded into the next, instead of being defined by sharp edges and large fields of color. With the stability of oil board, Hicks could then build up color layers, as well as add layers of stencil that would stay put to create a precise image. Oil board allowed Hicks to develop his signature technique of "sculpting" color, which is a process of slowly adding sprays of lighter hues to a dark background to gently pull out detail. Using lightly pressured sprays of the can, he could create feathering strokes that, once built up, could emulate skin tones, clouds, or dramatic lighting with detail that straight stencils could not. With this process, Hicks has developed an oeuvre of works on canvas, paper, and panel that appear to be photorealistic, due to the spray control and understanding of color application he has developed over the years. This detail means that it is extremely important to have totally perfect registration, or lining up of stencil layers.

Because of its durability, oil board can also be cut with a laser cutter, for making more detailed or extremely large-scale stenciled murals. Each layer is tiled in order to fit the laser cutter's standard size, then must be taped together to make one layer. Whether making a mural 10 feet (3 m) or 100 feet (30 m) long, Hicks meticulously tapes together each layer, precisely lining up each sheet in order to get his desired photorealistic effect.

Called a painter with a photographer's eye, Hicks largely focuses his work on the perception of the urban environment, at times humanizing its architectural angles and structures, and at others using its vastness to explore identity, awe, and solitude. Through an almost Old Masters approach to lighting, Hicks has learned to manipulate ordinary architectural scenes into deeply metaphorical and contemplative imagery, compounded by his use of color in the studio.

Saved, 2015. Spray paint on canvas.

Wonder Wheel, 2015.
Spray paint on paper.

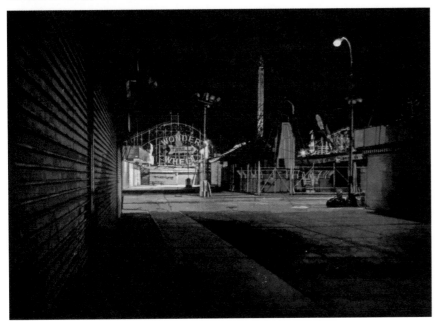

Exploring the Beauty of Architecture

When looking at Hicks's images of vacant New York alleyways, cobblestoned streets in Brussels, or expansive views of Athens, the artist's process is not immediately forthcoming. The images are on one hand nearly photorealistic, but on the other, bear purposeful sputters of spray paint that Hicks has infused to show his hand. This gauzy precision, a contradiction in itself, is a process Hicks has perfected over the course of many years, balancing architectural precision with the chaotic markings of the spray can.

The pristine angles of Hicks's chosen cityscapes and the soft shoulders of his subjects are due to their source: original photographs. As his vision has grown to require sophisticated and sometimes complicated imagery, Hicks has combined his photography with his stencil making, elevating the limits of hand drawing. Using photography allows the artist to tweak and refine images using computer manipulation, modernizing the rudimentary stencil-making process.

The artist's process, Baltimore, Maryland, 2014.

Hicks's detailed outdoor murals can be found around the world, notably in Miami's Wynwood Walls, Amsterdam, Sweden, Tunisia, and on New York's famed Bowery Wall in the summer of 2016. His studio works have been shown in galleries and museums in New York, Paris, London, Istanbul, Norway, Amsterdam, San Francisco, and beyond.

Artists like Logan Hicks have not just pushed stencils to their limits but have also helped the medium evolve from a simplistic replication process to a complicated and respected medium for the fine art world.

JOE IURATO

ENVIRONMENTAL STENCILSCAPES — New York Area, New Jersey

The Moon and Antarctica, New Jersey, 2013. Spray paint on wood.

FACTBOX

- Joe Iurato uses spray paint primarily in black, white, and gray.
- The artist is known for using stencils to create small woodcut characters that he juxtaposes in urban and rural environments before photographing them.
- He also leaves his stenciled woodcuts around cities he visits for passers-by to find.
- Iurato hand cuts all of his thick cardstock stencils with an X-Acto knife.
- He sharpened his stencil skills by working with Logan Hicks as an apprentice.
- Iurato balances his visual art career with his work as a sommelier in New Jersey.

www.joeiurato.com

Coming across one of Joe Iurato's grayscale stenciled woodcuts on the street is like finding a four-leaf clover—an unexpected moment of joy. The New Jersey native has spent a considerable amount of the past few years placing miniature woodcut figures in cities around the world, juxtaposing his characters with the environment around them to create a narrative waiting to be discovered by passers-by. Spray painted from cut stencils, the flat wooden figures embody a photorealism, which is broken by Iurato's choice to use just black, white, and gray tones. Placed in familiar urban settings, the miniature spray-painted stencil works take on a more personal experience for the viewer, which is matched with Iurato's intimate subjects of family, adventure, and urban living.

Mixed-media installation, exterior and interior, Station 16 Gallery, Montreal, 2015.

A Fixation on Hand-Cut Stencils

Spray paint has always been the medium of choice for Iurato, who hand cuts his own stencils to create murals and studio pieces. Using cardstock to cut each stencil layer, Iurato works both from his own photographs and in collaborative pieces with other photographers. The cardstock stencils are then used to create multiple pieces of each scene.

Years of studying filmmaking, graphic design, painting, and illustration at community college and Montclair University left Iurato feeling unfulfilled, so he decided to switch

gears and become a sommelier. He also was working as an editor for an urban rock climbing magazine, which has had a big influence on his imagery. These varied experiences coalesced when he began experimenting with stencils, with his studies in filmmaking and rock climbing reflected in his source photos. The transferring of photo to line drawing came from his classes in graphic design and illustration, and his painting courses lent the knowledge of how to fill in the stencils with color. Wanting to hone his stencil-making skills, Iurato worked as a studio assistant to Logan Hicks for a few months. Under this mentorship, Iurato didn't glean Hicks's stencil techniques but instead

studied how Hicks tailored his stencil work to fit his own personal vision, in addition to learning how a practicing studio artist works day in and day out.

Under Hicks's tutelage, Iurato also learned to experiment. Because spray paint is readily available and inexpensive, Iurato was able to explore the medium, using different techniques with the same reusable stencil. He focused on scenes that often centered on a strong figure, sourced from a photograph taken by him or a collaborator. He settled on making the figures with solid, flatly painted fields, created by applying spray paint evenly on each layer. Iurato soon began making life-sized paper stencil mural pieces, working in white, black, and gray for

the figures, and the occasional color for props or accessories within the stencil. As he continued to use walls as his canvas, Iurato began finding limits in stenciling, not only due to the size and exactitude of the material, but also because of a mural's ability to interact with its environment. Although a mural on the street could be read in relation to its urbanity, the prevalence of murals around the world has somewhat desensitized the viewer, and created the context of an outdoor gallery rather than an urban intervention.

Take The Train, New Jersey, 2014. Spray paint on wood.

"There isn't another medium that could yield the results I want to achieve with cardstock stencils. Paint application with a roller, brush, or sponge wouldn't give me the clean edges and even layering that I prefer for my work. Also, the use of spray paint allows me to use the stencils multiple times before discarding them. The only contact made with the paper is the paint, which can be controlled and applied with consistency."

RISK and REWARD, Miami Marine Stadium, Florida, 2014. Spray paint, latex, and wood.

Dope, Miami Marine Stadium, Key Biscayne, Florida, 2014. Spray paint on wood.

Scaling Down to Find His Signature

Wanting to engage his pieces within the urban environment, Iurato drastically scaled down his work and began a series of spraying stencils onto small wooden cutouts. At no more than 15 inches (38 cm) in height, the stenciled cutouts were durable enough to fit into any landscape, held sturdily in place by strong epoxy, wire, or nuts and bolts.

Whimsical Woodcuts

Iurato's miniature pieces opened a portal to creativity for the artist, enabling him to create intricate narratives within city streets. This new body of work delves beyond the current commonality of street art, but harkens back to the initial spirit of the street art genre, which felt like a surprise or discovery when a viewer would stumble upon a piece hidden in the dense urban landscape. The scaled-down cutouts have also inspired a series of photographs, in which Iurato has captured his spray-painted pieces placed in his chosen street settings, immortalizing them before they are destroyed by the elements, vandals, building owners, or adoring fans. Some pieces only remain up for an hour or two before being removed, but Iurato enjoys the ephemerality of putting work on the street.

Constantly pushing himself, Iurato allows his work to evolve easily. Just as each artist searches for his or her individual, defining style, Iurato's decision to spray paint his figures in only whites, blacks, and grays has helped give him a distinct identity, while evoking a flashback to a nostalgic time, much like classic black-and-white films are perceived today. Whether he is painting pieces of his two young sons, an old blues musician, or even Mike Tyson (whom he painted for Tyson's gym in Florida), Iurato lets his lack-of color palette make his work recognizably his.

Today, Iurato continues to spray paint large-scale pieces for mural projects as well as for commercial clients, including Nickelodeon, the USA Network, Adidas, and ESPN. His fine art passion—his stenciled woodcut environmental interventions—have appeared along with gallery exhibitions in New York, Montreal, Berlin, Miami, Paris, London, and Borås, Sweden.

NICK WALKER

V IS FOR VANDAL — Brooklyn, New York, and Bristol, United Kingdom

Amour Plated, 2016. Spray paint on wood.

FACTBOX

- Nick Walker was part of the initial stencil movement of the 1980s.
- He first dabbled with spray painting graffiti as a teenager using the tag EGO.
- Walker was commissioned by Stanley Kubrick to recreate the graffiti in the streets of New York that appeared in the movie *Eyes Wide Shut.*
- The Bristol-born artist splits his time between the United Kingdom and New York City.
- Walker is most known for his Vandal character, who wears a traditional bowler hat and striped suit.
- Walker's spray-painted stencil works have sold for more than $70,000 at auction.

www.theartofnickwalker.com

British artist Nick Walker has become known as a leading stencil master, recognizable for a stark and flat photographic style that defies realism by embracing the nuances of the medium. Working between his hometown of Bristol, UK, and New York City, Walker created his signature Vandal character, which has become iconic within the art world, and has left his mark on the walls of New York, Paris, and beyond. After more than twenty years making stencils, Walker has developed a style that adheres to the precision that cut stencils allow, mixed with the beauty of grit and natural spatters that spray paint makes. Walker uses city skylines and characters like Vandal to lightly poke at social and political issues with wit and humor.

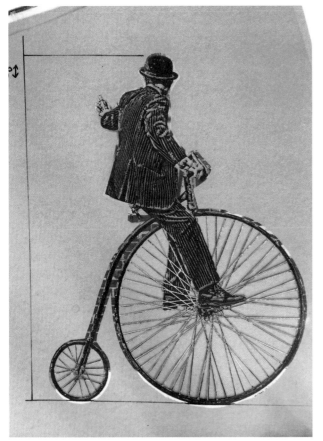

Penny Farthing Vandal, 2015. Spray paint on paper.

Quin Hotel, 2016. Spray paint on canvas.

1980s Graffiti and Buffalo Gals

Like many artists coming up in the 1980s, Walker first cut his teeth in the graffiti world under the influence of the subway art coming out of New York City. Music videos like Blondie's *Rapture* in 1980 and Malcolm MacLaren's *Buffalo Gals* in 1983 made their way over to the UK, influencing a whole school of artists who began to emulate the Wildstyle shown in the videos on the streets of Bristol. Like the graffiti writers in New York, Walker chose a handle—EGO—which he tagged all over Bristol. To Walker, this time was about spray painting freehand, practicing over and over until he could make perfect lines with no overspray.

Painting the Streets in a Bowler Hat

Walker's freehand style gave way to stencils in the early 1990s, after his friend 3D (Robert Del Naja of the British trip hop collective Massive Attack) began to experiment with the medium. Confused at first by how stencils could be integrated into graffiti, Walker became attracted to their ability to replicate photographic realism. He soon began to experiment, combining photographic imagery with a purposeful style that accentuates the rawness of spray paint, with splatters and sprays as part of his aesthetic.

With freehand work, artists could abandon ship if they thought they'd be caught illegally painting a wall. But with stencils, the process could be a bit more meticulous, making for a more difficult getaway. With his newfound love for the accuracy of stencils, he began to dress in a way not to be noticed when painting covertly. Rather than dressing like a stereotypical graffiti writer in paint-covered clothes and bandana-covered face, Walker went with the British streotype, donning a bowler hat and pinstripe suit while painting illegally—all under cover of a large umbrella. This disguise worked as a means to spray paint on the streets quickly, and without as much suspicion.

Boogie Down, mural, 2015.

Brooklyn Bridge, stencil.

The Birth of the Vandal

Walker's chosen disguise garb quickly made its way into his work, becoming one of his most iconic characters: the Vandal. The Vandal is a gentleman, a man of mystery, who infuses a certain charm into his graffiti. With the Vandal character, Walker has almost removed the artist's hand from the work, thus somewhat removing the blame for vandalizing a building. When a building owner sees a spray-painted character, he sees the artist as the cause of vandalism. But in Walker's pieces, the Vandal character is in fact the one painting. By transferring the spray-painting act to a semi-photorealistic character, Walker has ingeniously added not only a narrative element of charm to the work but also removed himself from the act. This simple juxtaposition gives Walker's stenciled pieces have more staying power on the streets, and make him one of the most recognizable street artists today.

The Vandal is joined by other characters that often infuse a tongue-in-cheek humor with a little political criticism, making Walker's work quite popular in both galleries and auctions. His posterior-flashing *Moona Lisa* piece sold for ten times its value at Bonhams Auctioneers in 2008, and his *White Panties/Nickers* series has also become well known. Walker uses the precision of stencils to render photographic architectural images, cutting the exactness of the line with carefully controlled, raw sprays of color to make painterly compositions.

> "The rise of the genre can only be a good thing if it allows myself and others to live off our art, and that I am truly grateful for."

Beyond the Vandal and into the Smoke Series

Most recently, Walker has developed a technique he dubs the "Smoke Series." With this technique, he focuses on the multilayering of stenciled numbers, a modern update to Charles Demuth's *I Saw the Number 5 in Gold*. With careful sprays, the layered numbers have a ghostly texture, emulating billows of smoke that magically comingle to fill out the formations of each letter. The process uses the stencil as a subtle guide, rather than filling it with solid spray paint.

Walker is keenly aware of the recent popularity of graffiti and street art, and is ensuring his longevity by developing new techniques and bodies of work like his *Smoke Series*. Now that the novelty of the 2008 boom has worn off, Walker has shown that his works are here to stay. His paintings and murals are consistently on exhibition around the world, with notable murals in New York, London, Hong Kong, Bristol, Paris, Los Angeles, and Stavanger, Norway.

Vandal Girl, 2015. Spray paint on canvas.

Bumbo Street Scene, 2015.
Spray paint on canvas.

4
GRAPHIC
EDGES

Sentry by Tristan Eaton, Guam, 2014.

While some artists are influenced by the shadowy misting properties of spray paint, others are attracted to its ability to create even, consistent surfaces. Unlike acrylics, oils, or even house paint, spray paint doesn't come with an added texture that affects an artist's imagery. The smooth surfaces and clean lines go hand in hand with artists influenced by graphic design, giving them the ability to paint smooth, evenly coated canvases and walls that emulate the continuous tones of digital printing.

Graphic design and traditional painting used to be thought of as polar opposites. But as digital platforms have taken over the world and become commonplace in day-to-day life, digital imagery has become fodder for many artists' creativity. Inspired by the lines of comic books, graphic design, digital imagery, emojis, and icons, graphic imagery has emboldened fine art since the 1960s, with fine artists bringing new emotion to this imagery by removing it from the computer screen and printed page.

To achieve the hard edges, bold colors, and crisp lines that are common to the graphic arts, a slew of artists have turned to working in spray paint for its accessibility and celebrated flatness.

Although some use masking tools or guides to achieve these immaculate lines, others have developed superior can control through practice, relying only on their steady hand. The quickness of moving imagery around a file in a computer design program is also echoed by using spray, with its fast-drying capabilities.

A mix of color, figures, typography, organic lines, and geometric shapes are given a tensile quality with continuous spray color, making vivid paintings that are comparable to digital imagery. San Francisco–based artist Casey Gray turns to Google Images for the source imagery for his paintings, directly translating digital to tactile by using spray paint and hand-cut tape masks. Artist Matt Eaton has created a body of paintings inspired by typography, transforming words and letters into geometry and organic shapes that are brought to life by using spray paint directly from the can, but also with a brush, squeegee, or palette knife. His brother Tristan Eaton is a spray paint purist who has developed an incredibly steady technique for freehanding hard edges and graphic images.

DIY

Painting A Graphic Scene with Caroline Caldwell

Painting imagery that resembles digitally produced art is all about the contrast of color and line. Using light colors with darker outlines is an easy way to begin to experiment with graphic edges. An array of flat and bold colors, combined with crisp, contrasting outlines using a skinny cap, will make figures that pop.

About the Artist

A recent graduate of Sarah Lawrence College, Caroline Caldwell is a young illustrator, painter, and writer based in Brooklyn, New York. Caldwell's personal work deals with themes of home, death, and rebellion. Her work questions ideas of property, through both surreal architectural illustrations and interventions in public space. She is also a regular contributor to the popular street art blog *Vandalog*, and has worked as a studio assistant to notable artist group Faile and Jeremyville.

1

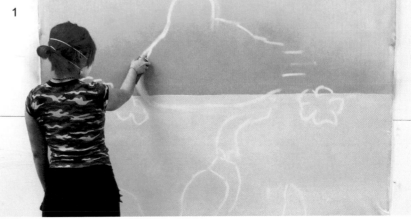

About the Project

This exercise is all about using solid lines to make an image pop. Much like in a cartoon or a comic, the background color lays a simple base, while the image's information is all in the line work. A guiding outline is then filled in solidly along with the background using simple colors, with the option of adding a fade to make the project more advanced. The piece is then polished with defining bold lines, which will make each component crisp and graphic, as if pulled from a digital image.

1. After adding your background, do an outline in a light/subtle color.

2. Fill in your subjects with a single flat color. Go back and forth in a straight line, evenly covering the surface area.

3. Give your subjects dimension by adding fades. Using a fat cap, fade at a distance toward the opposing color.

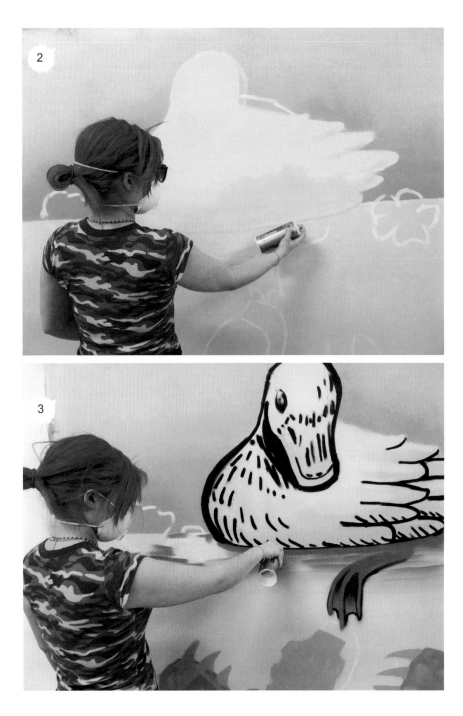

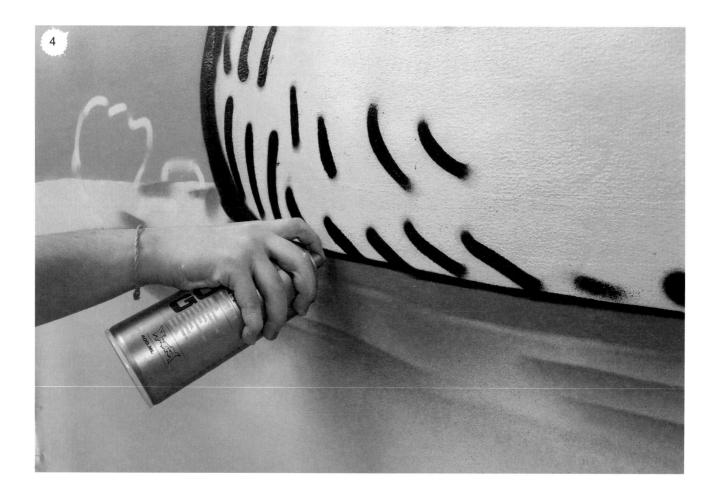

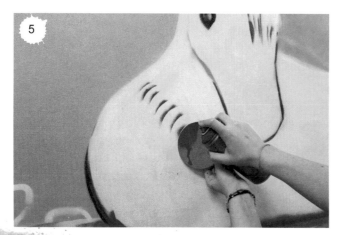

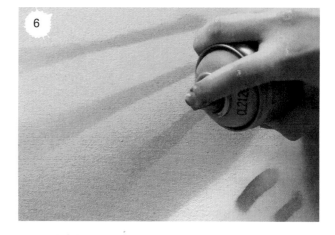

4. To add outlines and details, use a thin cap. The closer the distance to the wall, the thinner the line. To get your lines the thinnest, face the bottom of your can in the same direction you're spraying the line. Move quickly to avoid paint buildup and drips.

5. For very fine shading, use stencils. To get the feather effect in this particular piece, the stencil needed to be rounded. By aiming at the edge of the paper, only a small sliver of paint actually made its way onto the canvas.

6. Make your lines thinner and cleaner by tracing over the edges with your background color. To get a thin line, press lightly on the very back of the cap.

7. To create a water effect, face your can downward with the nozzle tip close to the canvas, but aim the paint slight away from the canvas.

8. For flares, use a skinny cap and radiate outward from your image, pulling away from the canvas as you go to widen the line.

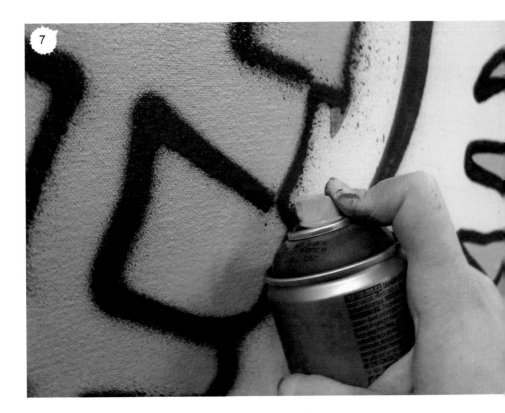

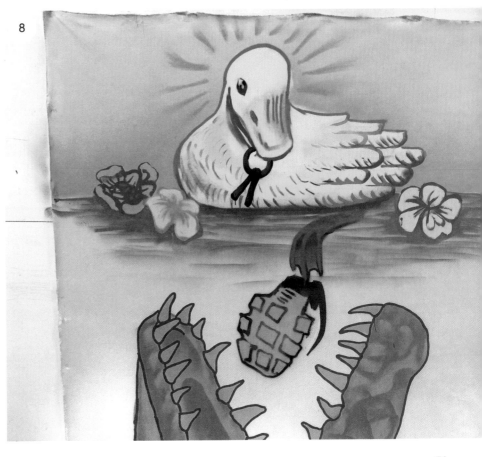

CASEY GRAY

EVOLUTION OF THE STILL LIFE – San Francisco, California

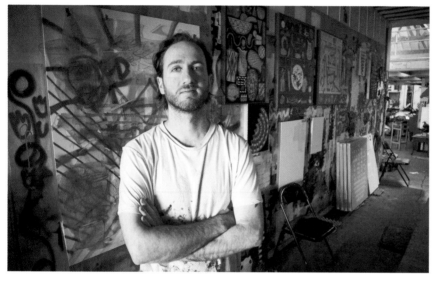

Studio portrait, 2015. Photo © Michael Cuffe.

FACTBOX

- Originally working in traditional acrylics and oils, Gray turned to spray paint to challenge the ideals of contemporary painting.
- He was educated at San Diego University and is based in San Francisco.
- Gray achieves sharp graphic lines through his top-secret self-developed tape and masking process.
- He does not consider himself a stencil artist, although he uses some stencil-like materials.
- Gray meshes modern spray paint with inspiration from eighteenth-century still-life paintings.
- The smoothness of spray paint allows Gray to emulate the flatness of digital imagery.

www.CaseyGray.com

According to Casey Gray, the medium of spray paint is entirely responsible for changing the course of his art career. The San Francisco–based artist began as any traditional painter might, working in acrylics and oils while studying painting and printmaking at San Diego State University. But in 2004, Gray put down his brush permanently, choosing to focus solely on aerosol paint to develop an approach to contemporary painting that is uniquely his own. With spray paint, Gray has made his mark on the art world with vivid still-life paintings inspired by eighteenth-century Neo-Classicism, which bear a graphic flatness that anchors his work in modernity. Hand-drawn masking techniques, clips of files from Google Images, and a dedication to acrylic spray paint define Gray's nontraditional style that fuses a history of art genres and processes into a cohesive body of work.

Casey Gray's detailed paintings read as excitingly graphic, with sharp lines, saturated colors, and deep shadows. Line and pattern interplay with recognizable objects—flowers, phone chargers, body parts, or pieces of fruit—all rendered with a sharp focus that is accentuated by dark backgrounds. His exhaustive detail is easily mistaken for digitally assembled imagery, bearing the hand of a designer instead of a painter. With spray paint, Gray has developed the ability to mimic the flatness inherent in digital media, a trompe l'oeil quality the artist attributes to the medium itself.

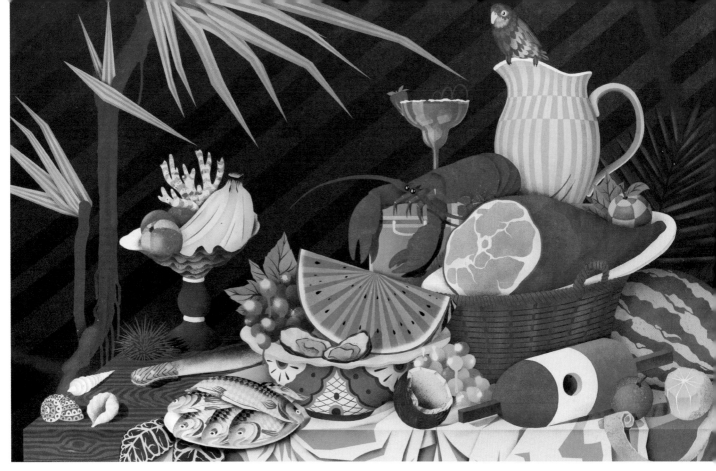

Still Life with Surf & Turf, 2015. Acrylic spray paint and spray enamel on panel.

Challenging Traditions of Painting

Gray adopted spray paint as a means of challenging popular conceptions of painting, while differentiating himself from other painters. Like many students in art school, Gray started out working in the mediums that the curriculum dictated—oils, acrylics, pencil, and ink. But with these typical mediums, he felt his work was lackluster and seemed to look identical to his classmates'. Looking for something to make his work stand out, he leapt into spray paint, a medium that was somewhat personal, and largely inspired by his grandfather.

His observations of his grandfather working with spray paint were amplified by an idea to bring spray paint stenciling, which Gray had used to decorate his skateboards, into his artwork. This introduction altered the course of Gray's work, creating the catalyst for his adamant focus on redefining fine art through spray paint. Finding stencils too limiting, Gray adapted and manipulated select properties of paper stencils to his own needs, using contact paper for its light adhesive to make graphic shapes that aren't dependent upon the bridging of stencils. Gray uses contact paper as a mask to create crisp sharp lines, peeling off areas and throwing them away after they've been sprayed.

Parrot, Lobster, Fish, Fruit & Tropical Drink, 2013. Acrylic spray paint on panel.

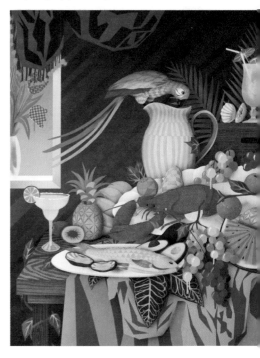

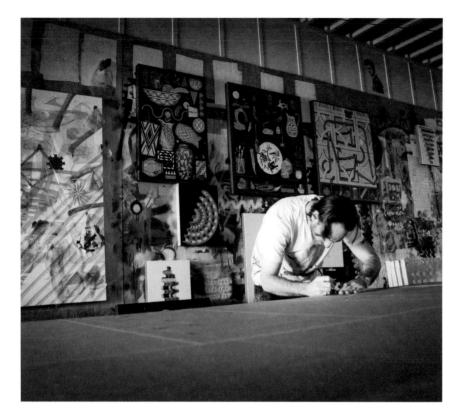

Gray in his studio, 2015. Photo © Michael Cuffe.

The Making of Masking

Although Gray does not identify as a stencil artist, he controls the power of spray paint with adhesive paper in the same manner as with paper stencils. With spray paint and his masking technique, Gray plays with textures, dimensions, and concepts, often within one painting. He prefers to use the bright colors and bold graphics of skateboard culture to illustrate chosen elements from art history, mixing the two into a unified style. Much of his work is inspired by the cabinet and still-life paintings of the eighteenth century, a genre that continues to be popular for its stoic and formal compositional style. Although these compositions are traditionally painted from life, Gray's versions are remixed, challenging the concepts behind the still life by using digitally sourced images instead of elaborate tableaus, in addition to the obvious modern implications of using spray paint over traditional oils. Both medium and method have influenced the scope of Gray's work more than a traditional painting medium might have.

Gray's decision to work in spray paint has made the artist not just a challenger of art traditions but also an accidental advocate for validating the medium in fine art, with his body of work becoming visual proof of the abilities of spray paint. Gray's dedication to the medium has not only shown its positive qualities, but also his penchant for referencing art history has created a relationship between oil painting traditions and the once-utilitarian medium of spray paint. The choice to use spray paint as his voice accentuates an interesting dialogue among a cast of his influences, such as skateboarding, graphic design, digital media, academic painting, and art history.

Still Life with Flowers No. 32, 2014. Acrylic spray paint on panel.

Still Life with Fruits & Flowers, 2015. Acrylic spray paint on panel.

Studio portrait, 2015. Photo © Michael Cuffe.

A Naturel Predliection, 2015. Acrylic spray paint on panel.

Chocolate & Vanilla, 2015. Acrylic spray paint on panel.

Tromple l'oeil with Net-flix & Chill, 2015. Acrylic spray paint on panel.

With his devotion to spray paint, Gray has carved a niche for himself in the fine art world, attracting both art history enthusiasts and modern art fans who relate spray paint to the urban art genre. Gray has continually mounted successful solo shows across the West Coast and has participated in group shows across the United States.

Garden in a Bullet, 2015. Acrylic spray paint on panel.

TRISTAN EATON

The Art of Can Control — Los Angeles, California

The Rocker, 2015. Spray paint, acrylic, and silkscreen on wood panel.

Factbox

- When he was eighteen years old, Tristan Eaton co-designed the famous rabbit-shaped Dunny Toy made popular by Kid Robot.
- He first started using spray paint for graffiti as a teenager in London.
- Eaton is the younger brother of Matt Eaton, who also appears in this book, and has acted as Tristan's manager in the past.
- Eaton is world renowned for his "clean" style of sharp can control, using bright colors to paint photorealistic collages pulled from popular culture.
- He acts as creative director and designer for his creative company, Thunderdog Studios, and is sponsored by the spray paint company Montana Cans.
- Eaton is a member of the artist group TrustoCorp, known for their humorous street signs and product labels.

www.tristaneaton.net

Tristan Eaton's work is a unique blend of dynamic collaged elements from advertising and pop culture, painted with an impeccability that is often perceived as digital montage. Eaton's superior can control allows him to transfer his experience as a designer with his company Thunderdog Studios, and as a founder and toy designer at Kid Robot, to the canvas or wall. His clean style of remixing portraits, graphic patterns, historical imagery, and comics into one comprehensive image has the same consistency of Adobe Illustrator mastery, remarkably achieved using only traditional spray paint.

Painter, Art Director, Toy Designer

Eaton is a modern Renaissance man, and his creativity flows into many facets of the art and design world, which carries over into his paintings. Over the years, he has built a successful portfolio of toy design, illustration, commercial collaborations with brands, art direction, and fine art. Although the artist is prolific in each of these subgenres of visual art, his focus resonates most with his murals and studio paintings. His commercial and design projects are treated with equal importance, but his passion lies with spray paint. His craft with spray is so refined that he has been fully sponsored by Montana spray paint.

Like many artists in this book, Eaton was first exposed to spray paint through graffiti in the late 1980s and early 1990s. For Tristan, graffiti became a practice through his older brother Matt (featured in the next section), who painted graffiti in England when their family lived there when he was a young child. A few years later, the family moved to Detroit and Eaton began to spray paint on the streets, taking inspiration from British illustrators and comic books he'd grown to love in the UK.

The Son, 2015. Spray paint, acrylic and silkscreen on wood panel.

The Nurturer, 2015. Spray paint, acrylic and silkscreen on wood panel.

Mural, collaboration with Matt Eaton, Pow Wow, Hawaii, 2015. Photo © Brandon Shigeta.

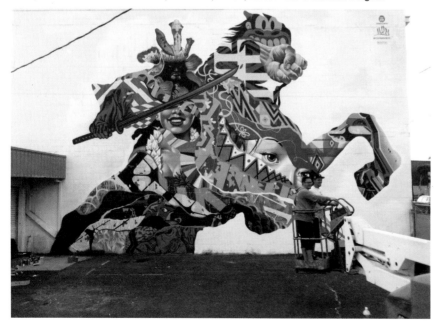

Graffiti was a means for Eaton to develop his artistic talents, letting loose on the streets of Detroit without the confines of pencil and paper. It was because of these years of unbridled creativity and spray painting that Eaton discovered his ability to render sharp, concise lines and incredible photorealism that other artists could not achieve. Despite making work on the streets for many years, Eaton does not consider himself a graffiti artist. Instead, he categorizes himself simply as an "artist," feeling his mishmash style would do a disservice to other talented graffiti writers should he categorize it as such.

Over time, Eaton has combined his stringent spray can talent with his experience as an art director and commercial designer to create his definitive style which continually brings him around the world for mural festivals and commercial projects. Eaton has a knack for replicating familiar imagery in photorealistic detail, including cultural icons, recognizable beauties from the media, and historical figures. He remixes segments and excerpts of these, together along with text and vibrant patterns akin to Pop Art and comic book art. Often the pieces fit together like a puzzle, each colorful fragment interlocking with the next to seamlessly create one tenacious figure or portrait. His understanding of his own imagery is exemplary, and most evident in his large-scale murals which feature negative spaces intersecting his picture plane without faltering color or perspective.

Clean Style for Commercial Projects

These cultural conglomerations have become Eaton's calling card, permeating his commercial, gallery, and mural work, which has reinvented architectural facades in cities across the globe. Eaton's work has a discernable dynamism and complexity that has consistently attracted commercial clients, especially lifestyle and fashion labels seeking to expand their brand with art. The artist's ability to mash up elements from a brand's identity into gorgeous murals is as alluring to his clients as their size. His murals often sprawl to expansive sizes, sometimes upward of 20 feet (6 m) and more, meshing art and branding, and have a much greater effect than any billboard ever could. Much like artist Shepard Fairey, Eaton's style transcends the genre and bleeds into commercial work, attracting clients for not only his skill set, but also his vision and brand understanding.

In the studio, Eaton, who describes his own style as "clean," continues to use spray paint, but has also made works that incorporate acrylics and silkscreen. As of late, the pieces to his puzzle have begun to take on a more personal, narrative theme. In his exhibition "Legacy," curated by Library Street Collective at Subliminal Projects in Los Angeles in November 2015, he replaced his token cultural icons with portraits of people who have played important roles in his life. His literal layering of imagery was matched with metaphorical layers, taken from audio interviews of his family, friends, and mentors who

Mural, West Palm Beach, Florida, 2014.

were asked to share stories about their lives. Visual elements from each story, as well as personal traits and memories from Eaton, were intertwined to create portraits that mix realism with abstraction. This first foray into the realm of sentimentality is also the subject of Eaton's first art book, aptly titled *The Murals of Tristan Eaton*, which was published in 2016 along with his first art object: a limited-edition "Art Can" produced by Montana Cans.

With his incomparable style and passion, Eaton strives to bring outdoor, public art to as many cities as possible, in hopes that it will inspire and intrigue locals and visitors alike. His detailed, large-scale murals can be found across his current city of Los Angeles as well as Miami, New York City, Detroit, Paris, Berlin, Guam, Mexico, and Sweden, to name a few.

MATT EATON

ABSTRACTED TYPOGRAPHY – Detroit, Michigan

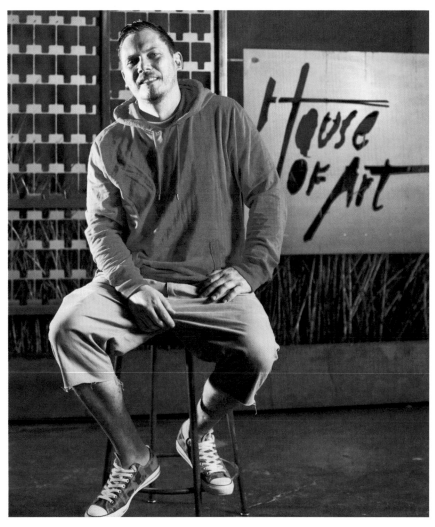

Portrait of the artist, 2014.

FACTBOX

- Matt Eaton, Tristan Eaton's older brother, first got into graffiti in the 1980s. Both Eaton brothers soon learned to love it.
- Eaton is obsessed with typography and calligraphy.
- When Eaton isn't painting, he is the curator at the Red Bull House of Art and co-owner of the Library Street Collective Gallery in Detroit.
- Eaton uses spray paint exclusively, as well as tools reserved for other mediums, like palette knives and brushes.
- He is inspired by the Japanese Superflat movement, which was popularized by Takashi Murakami.

www.matteatonasnobody.com

Layer upon layer upon layer. Matt Eaton's art-making methods are based on a continual layering of spray paint, building up shapes, patterns, and colors until it just feels right. With spray, Eaton explores a bevy of inspirations—typography, calligraphy, texture, color, and decay—unified by the continuous flatness of the medium. These incessant layers are made in a meditative process that is just as important to Eaton as the finished paintings. The fast-drying properties of spray allow the artist to indulge in his sacred action of building up shape, line, and letter to create rich paintings with bold fields of color and delicate lacelike intersections.

The Brothers Eaton

Art and spray paint run deep in the blood of the Eaton family. Both brothers were introduced to spray paint as their medium of choice thanks to the London graffiti world, before transitioning into professional studio careers in New York. While Tristan's career took him to Los Angeles, Matt relocated to Detroit to focus on his own work and to become partner in the Library Street Collective Gallery, where he consistently works with artists using an array of mediums. But despite a constant flow of influences, he remains dedicated to making work in spray, entranced by memories of his teen years spraying graffiti in London.

Aerosol and Out of the Can

Because it has been many years since Eaton has painted graffiti, his usage of spray paint has evolved with his style. A combination of traditional sprays and manipulations of the can give each of Eaton's layers the hard, graphic edges that discern one from the other, creating composites with the vibrating edges of contrasting colors and clean lines. Borrowing methods primarily used with other paint mediums, Eaton has created his own style and process while sticking to his roots.

MICROSTRUCTURE No. 23, 2015. Spray paint on linen.

SUPERSTRUCTURE No. 43, 2015. Spray paint on linen.

COUNCIL OF LIGHT No. 8, 2014. Spray paint, ink, and acrylic.

RECTANGLE No. 3, 2014.
Spray paint on linen.

The Sleekness of Spray

Relying on nothing but spray paint (both sprayed with a cap and expelled into a palette using painting tools), Eaton's paintings have a smooth, continuous finish that give a look of fine printing from digital files. Crisp edges of shapes inspired by calligraphy, and veins of dark color positioned over bright hues, are often mistaken for layers in Adobe Illustrator, but the flat surface and precise lines often betray the hand-painted quality of his work. This digital trompe l'oeil is achieved through Eaton's repetitive actions of building up layers of graphic shapes borrowed from personal influences and experiences. With a thicker medium such as acrylic or oil, this illusion would be broken as an unavoidable texture would build up over layer upon layer, but spray allows a sleekness of surface that lets Eaton continue to layer imagery without thinking about textural consequences. When creating work, Eaton takes on a method of automatism, adding shape and color with no preconceived design in mind, with results evoking the Japanese Superflat movement popularized by Takashi Murakami.

> "I still use spray paint in some traditional ways, but most of my application and technique involve opening the cans after releasing the propellant and mixing the pigment with solvents so I can apply it with a brush, squeegee, or palette knife. It's much more like traditional painting or watercolor this way, but it dries ten times faster. I also love putting my trust in the unknown and discovering the happy mistakes that occur when using a material in a way it wasn't necessarily designed for."

SUPERSTRUCTURE No. 42, **2015. Spray paint on linen.**

Text and Layers

This influence of the cities Eaton has lived in is echoed in his layering style, which is comparable to the multi-lined flatness of a traditional road map, long before GPS and smart phone apps. His layering style is meant to invite viewers to experience more than meets the eye, offering a new experience when the piece is viewed at different vantage points. What appears as a simple pattern from afar may be seen as a tangle of color, line, and depth up close. These complex compositions may be the perfect metaphor for the artist himself, who divides his life among being an artist, a curator, and an art dealer. These three facets intersect, harmonize, and sometimes contrast, requiring Eaton to have an in-depth understanding art, art history, and art commerce all at once.

Although Eaton has dedicated much of his career to helping other artists at both the Library Street Collective and as curator of the Red Bull House of Art in Detroit (and previously Contra Gallery), he continues to produce spray-painted works in the studio and in outdoor collaborations with his brother Tristan.

5

FACE AND FIGURE

Mural by Tatiana Suarez, Isla Mujeres, Mexico, 2014.

Face, figure, and form have been the focus of artists for thousands of years, inspiring with the subtle beauty of the human body. Figure drawing has been a basis of traditional artists' practices and education for centuries, teaching not just anatomy but also the nuances of grace with live nude models. With figure drawing, artists learn to sculpt curves and softness with minute detail, traditionally using pencil or charcoal, and sometimes followed by brush.

Challenging this tradition, contemporary artists use spray paint as if it were pencil, using a less controllable medium to render the same detail and curvature. With spray, artists link the past to the present, manipulating modern mediums to carry on art historical traditions.

Spray itself has proven to be more difficult to control. The artist is required to learn the characteristics of each nozzle, as well as how to work with a pressurized material (rather than simply controlling a static piece of graphite). An added layer of skill and attention to detail has not deterred artists from using spray, but instead has inspired myriad artists to master the can to create a body of work incorporating portraits and form.

Using the wide spray and coverage of spray paint, faces and curves are built up as if a sculpture, filling out fleshy shapes and tones with aerosol.

The Oakland–based artist known as Hueman uses spray to bridge the gap between abstraction and portraiture with her colorful pieces. Brooklyn artist Elle uses the portability of spray to paint massive images of women on rooftops and walls, meant to watch over the neighborhoods in which they take up residence. Tatiana Suarez fuses her parents' El Salvadorian and Brazilian heritages to depict sensual and stunning female forms, while Conor Harrington remixes historical portraiture to challenge contemporary sociopolitical issues.

DIY

Painting a Glam Portrait with Caroline Caldwell

The misty properties of spray paint can make for a beautiful skin color palette when painting a portrait, allowing the artist a faster option than traditional oils and acrylics. Using curved outlines, filled-in flesh colors, and distinguishing details, you can create a large-scale portrait in under an hour. Caldwell breaks down simple steps for a forgiving process that allows corrections or missteps to easily be fixed, using a standard universal cap throughout with simple blending that is easy for a beginner. Switch out your own color preferences and hair length to suit your personal style.

About the Artist

A recent graduate of Sarah Lawrence College, Caroline Caldwell is a young illustrator, painter, and writer based in Brooklyn, New York. Caldwell's personal work deals with themes of home, death, and rebellion. Her work questions ideas of property, through both surreal architectural illustrations and interventions in public space. She is also a regular contributor to the popular street art blog *Vandalog*, and has worked as a studio assistant to notable artist group Faile and Jeremyville.

1

About the Project

Mastering a face is a forgiving process that combines organic shaped outlines with fleshy fill-in color. Once you're confident with the overall underpainted shape, attention turns to detail. Using cans of white and darker shades brings out the facial features and shadows, creating dimensionality that will elevate your piece from cartoon to portrait. The final piece can be tweaked and personalized with different colors, eye shape, and hair.

1. Roughly sketch the outline for the piece. Use a light color like yellow so that it's easily hidden by your first fill color.

2. Fill your outline with flesh tone using a blending motion, then use a slightly darker color to discreetly lay out the placement of the details with light markings. Identify the direction of the light source, then block out the darker areas of the figure in two sections: midtones and shadows.

3. Blend both midtone and shadow so that they become a gradient. Blend by holding the can farther away from the canvas, giving a less intense application. This creates dimension and makes the piece come to life.

4. Add an outline color. This is the darkest color on the piece, and will only be added in small strokes. Add highlights with white. These should be only a few very small spots to add more dimensionality.

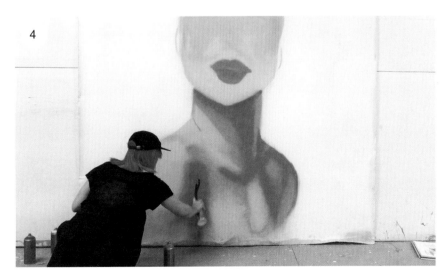

5

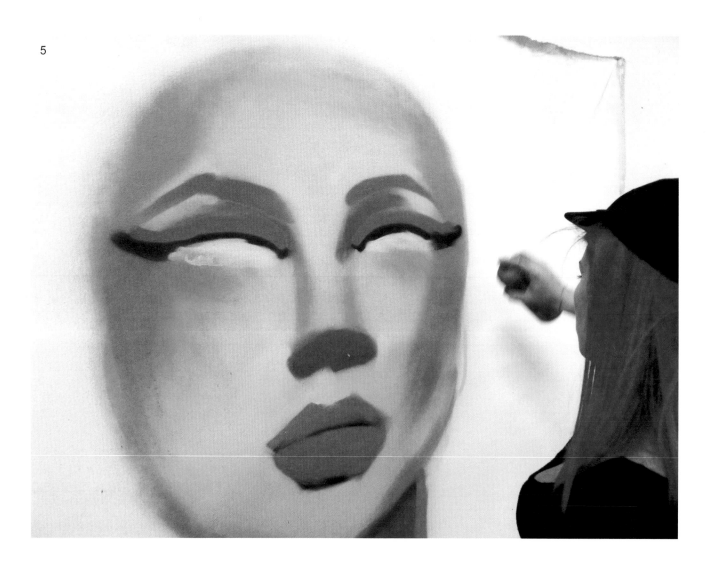

6

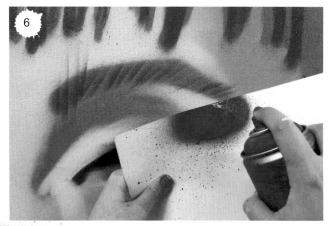

7

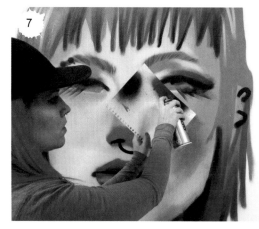

5. Build dimension by layering color. Hold the can about 4 inches (10 cm) away from your canvas and sweep across in light sprays.

6. Add hair detail. Use a sturdy piece of paper or cardboard as a stencil to create eyebrow lines.

7. Use a piece of paper to make wispy eyelashes, moving the paper along the under eye for each lash.

8. In a different color, add a secondary light source for a neon effect, adding subtle colored highlights with light sprays.

HUEMAN

Spray Paint and Signs of Life — Oakland, California

Hueman in her studio, 2015.

Born as Allison Torneros, Hueman has become known to the street art world for her ethereal murals of bold colors, fragmented portraits, and prismatic shapes. With her paintings beginning in an intersection of line, shape, and spontaneous color, the Oakland–based artist follows the plumes of spray paint, allowing them to dictate the direction a painting will take. Her pieces are a perfect balance of chaos and control, in both execution and presentation. Abstract color fields caused by the force of pressurized spray encompass her desire for chaos, making spray paint not just an art medium but also a catalyst for each piece. The spray chaos is controlled with tight painted lines that emerge from the sprayed color fields, which Hueman uses to slowly build up the faces she sees in her work.

Drawing and painting since a young age, Hueman studied digital/media arts at UCLA, focusing on digital art. Her foray into painting was largely self-taught, including her introduction into working with spray paint. Spray paint has always been an element in her paintings, serving mostly as a starting point of color wash. Choosing spray paint for its ability to create cloudy, gauzelike color fields, Hueman then uses these diaphanous layers to spark hidden shapes and faces within the color fields.

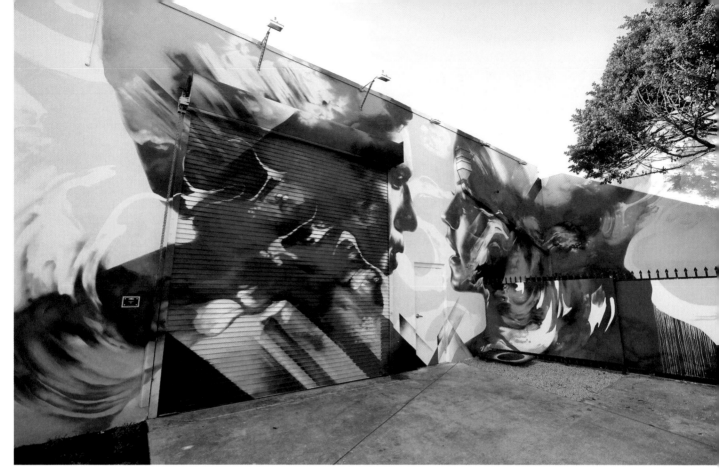

Wynwood Walls, Miami, Florida, 2015.

Letting Faces Emerge from Abstraction

Hueman's body of work, greatly inspired by space and cosmic imagery, has a celestial undertone, often with an intermingling of cloudy, gauzy organic shapes cut with sharp lines. The mixing of these two elements creates a pareidolic illusion for the artist, who finds images of faces within these colorful markings. After spotting a nose or an eye shape within her applied colors, the faces are then refined with more color wash and line. In the studio, Hueman combines spray paint and acrylic to make her washes, taming the tangle of colors with a brush to pull out and refine her images. Often working on more than one canvas at once, she alternates between pieces until a composition reveals itself. Referring to her process as a science, she continually adds and subtracts elements, letting the results shape themselves until all of the parts work in harmony. Too much softness will result in a hard line, and vice versa—a conglomeration of geometry will be reworked with a spray of color mist.

Mural, Los Angeles, California, 2014.

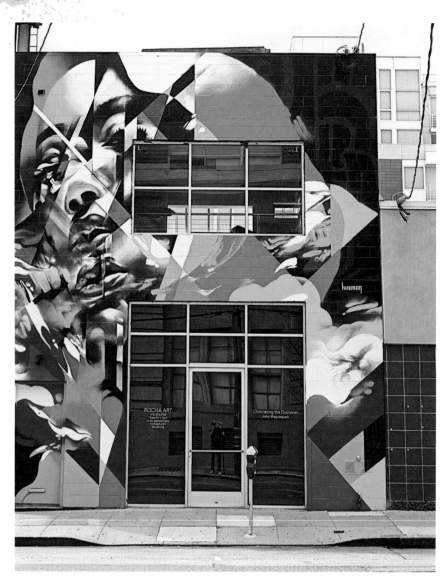

Mural, San Francisco, California, 2015.

> "Spray can be very versatile, and it helps me achieve a cloudy, dreamlike aesthetic. Using a brush on a wall and trying to get the cloudy effect that I'm looking for would take forever to achieve, and is more physically exhausting."

First Steps at Murals

While mastering her studio work, Hueman attempted to transfer her spontaneous, free-flow method by trying her hand at her first outdoor mural in 2006. She quickly found that her organic process was a liability when trying to fit within the often imposed time constraints of mural festivals or working with a client's timeline.

Undaunted, she found a compromise by making mock-ups for her large-scale murals first in the studio. This enabled her to still follow her method of letting paintings develop naturally, but also created a framework for working outside. She still allows for some spontaneity with spray paint for large-scale murals, but has a sketch plan to stick to.

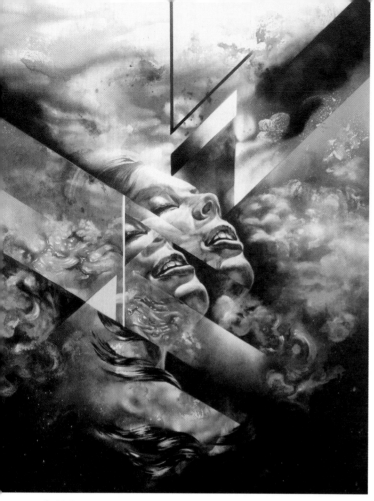

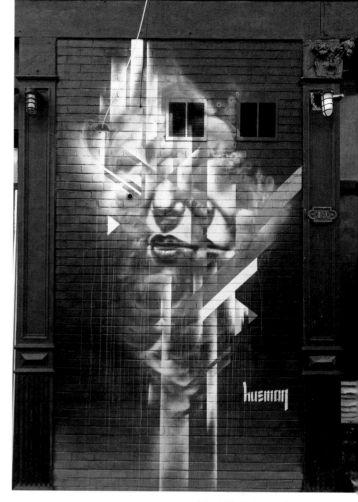

Bubbling Beneath the Surface, 2014. Spray paint and acrylic on wood.

Black Magic Mural, 2015.

The Waiting Game, 2014. Spray paint and acrylic on canvas.

With the variety of spray paint available, Hueman has been able to replicate her controlled clouds that she makes in the studio on a large scale. Working with the same consistency, she treats murals just as her smaller canvases, staying true to her vision and style. Her outdoor murals have welcomed a new fleet of admirers, who may not otherwise see her work in a gallery setting. Spray paint has opened up the scope of both her art career and her fans, democratizing her audience by inviting people on the street to form connections with the murals they encounter. Many then seek out her studio work, becoming fans in their own right.

Hueman has exhibited her studio work extensively across the West Coast, New York, and London. Her beautiful mural work can be found in Miami, Oahu, New York, Los Angeles, and San Francisco.

ELLE

Watching Over Us — Brooklyn, New York

Painting on Brick Lane, London, 2016. Photograph © Nika Kramer for Urban Nation.

Brooklyn-based artist Elle has made a name for herself with her vibrant neon-colored murals around the world. Taking inspiration from the French translation of her self-imposed name (*elle* meaning "she"), the artist has focused her body of work on a female-driven message. Her murals of larger-than-life-sized women act as guardians, "watching over" the streets they appear on, in addition to establishing a strong female presence in the male-dominated world of street art. Known as a daredevil, Elle is no stranger to scaling walls or climbing billboards while armed with a rainbow of spray paint, painting her signature faces and figures on billboards and rooftops. Using a dynamic color palette of jewel tones, Elle tirelessly travels for her art, painting large-scale murals in cities around the globe and taking influence from the local cultures she visits.

Elle's art career began traditionally, by studying studio art and art history at the University of California, Davis, and later traditional oil painting at Brandeis University. But the life of a classical painter did not hold the passion Elle had hoped for. Her life, and the direction of her art, changed when she moved across the country to New York City.

New York as Her Muse

New York is a city like no other in America. The creative spirit is everywhere, from the brick wall next to the subway entrance to the more structured galleries of Chelsea. Here, Elle found her artistic passion, rooted in her introduction to East Coast street art. While visiting galleries in Chelsea, she came across two monumental pieces of street art in the area that changed the scope of her voice—one by celebrated Brooklyn artist Swoon and the other by Baltimore-based Gaia. She became fascinated with the active movement of street art in New York. Moved by the images and experience, the young artist began making wheat pastes and putting them up all over the city. This entrenched Elle in the world of street art, leading to a life of mural art and spray paint. She quickly carved a place for herself in the scene and was exposed to the less traditional methods and materials popular with street artists that later became integral to her work and process.

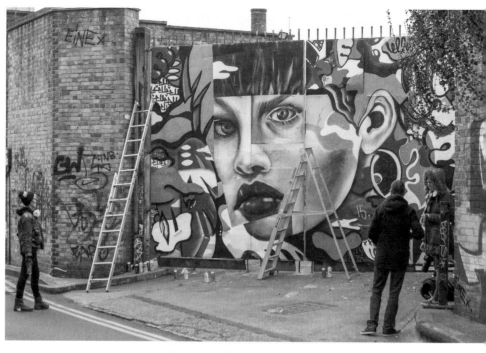

Painting on Brick Lane, London, 2016. Photo © Neil Cordell.

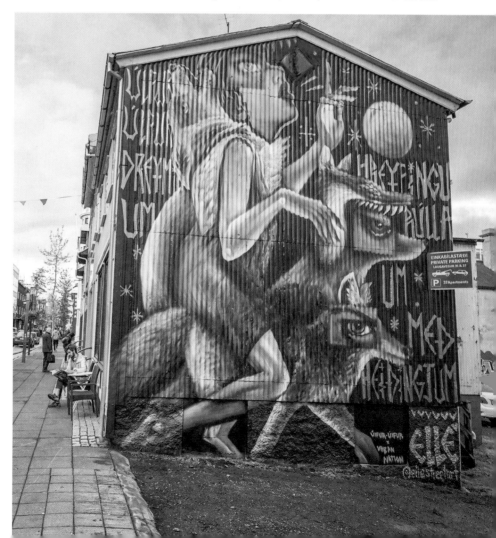

Painting on Brick Lane, London, 2016. Photo © Nika Kramer for Urban Nation.

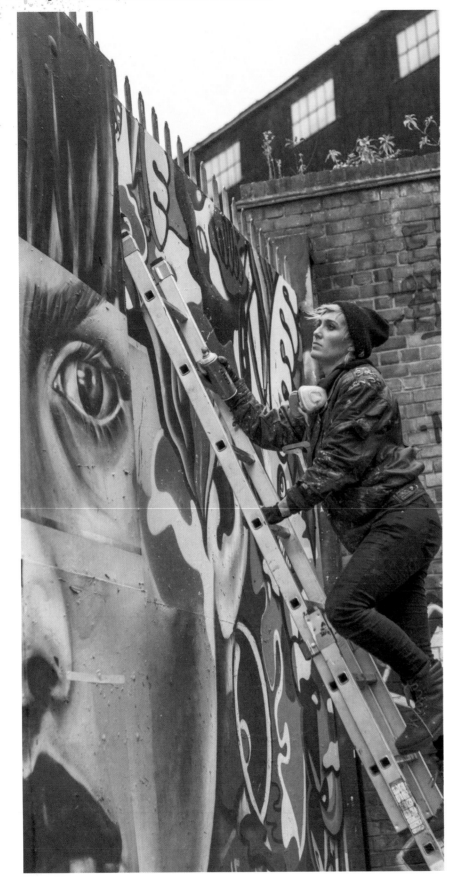

The next few years were spent making a name for herself, attracting an audience by putting up a copious amount of wheat pastes, stickers, and murals on the streets. This led to a pinnacle moment in her career: a joint solo show with street-art photography legend Martha Cooper, which secured her a sponsorship with the well-known paint brand Liquitex. Elle's newfound abundance of spray paint now gave her the freedom to take on large walls without reservation, solidifying her work as a mural artist.

Painting with a Free Hand and Her Whole Body

Elle's style and process are both dependent on the properties that spray paint allows. Unlike many artists in her field, she chooses not to work with projections, enjoying the physical expression of body, brush, and can that drawing freehand gives at a large scale. The reward comes from the struggle and satisfaction of walking away from a piece executed as she intended, and from her hand. This free-formed mode of expression is also reflected in her choice of tools— she has been known to enhance her spray work with everything from fire extinguishers to rollers, markers, and acrylic. Because Liquitex is water-based, she can incorporate other types of paint when needed.

Constant travel has become a perk for a female street artist in a world of mostly male-dominated international mural festivals. Because of Elle's jetsetter ways, it's no surprise that her monumental woman warriors adorn sidewalks, street corners, and billboards all over the world.

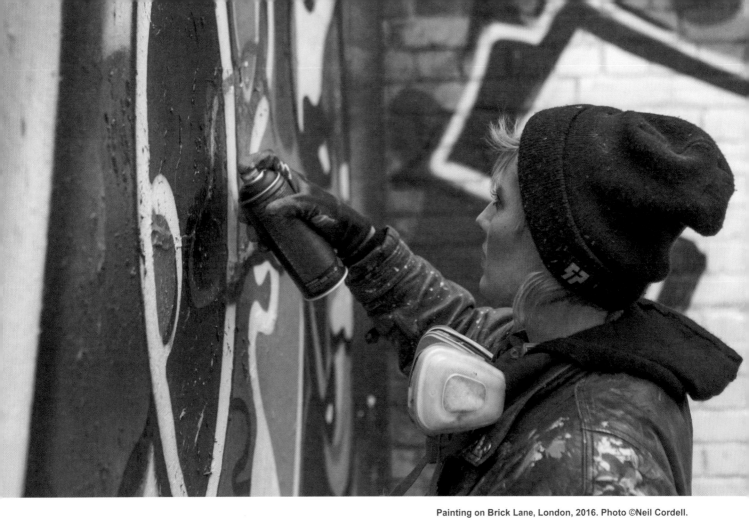

Painting on Brick Lane, London, 2016. Photo ©Neil Cordell.

She recognizes that the rise in popularity of street art has increased her opportunities to travel and believes that it's important to focus on the people in every place she's invited to paint. Each new location is met with an openness and sensitivity for the local culture, allowing her changing surroundings to inform the subject matter and context for the work she creates.

Elle's work is now embraced and celebrated all over the world, and she currently has murals in New York, Los Angeles, Mexico City, San Francisco, London, Vitry-sur-Seine, Berlin, and Amsterdam. She has painted in Israel and Malaysia with Urban Nation, and

she has a piece installed at the Urban Nation Museum in Berlin. Her work was featured in a 200-foot (61 m) video projection on the facade of the New Museum in New York City. In 2015, she was one of the twelve artists globally commissioned by IKEA to produce a poster as part of a street art series, and she has participated in many other corporate collaborations, including projects with the Guess Foundation, Lyft, and the clothing brand Mishka. In 2016, she exhibited at Saatchi Gallery in London. In addition to her mural work she's focusing on ad takeovers, inserting hand-cut colored Mylar collages on the sides of bus shelters in place of advertisements.

TATIANA SUAREZ

THOSE EYES — Miami, Florida

Portrait of the artist. Photo © Oliver Toman.

Strong and sensual female forms are the focus of Miami-based studio and street artist Tatiana Suarez. The powerful women she depicts on both wall and canvas embody a dynamic grace unique to the artist's sensibility and background, and touch upon broader themes of self-expression and sexuality. These ladies all share the artist's trademark doe eyes that enhance the astral mood and sensuality of each piece. Suarez manipulates cans of spray paint to achieve creamy blends, using it to build soft transitions inside curved and slightly abstracted bodies and backgrounds, and creating muted narratives with strong sultry allure and mysterious protagonists.

FACTBOX

- Tatiana Suarez is based in Miami and is known to her friends as Tati.
- The artist is known for painting sensual female forms with brooding doe eyes.
- She is influenced greatly by the cultures of her El Salvadoran father and Brazilian mother.
- She loves to use spray paint in a sideways, sweeping motion that lets her dust color across large areas.
- She was first asked to spray paint a mural by Miami's iconic Primary Flight program in 2009 during Art Basel Miami.
- Practice makes perfect. Suarez struggled with spray painting murals at first, but taught herself techniques over time.

www.tatisuarez.com

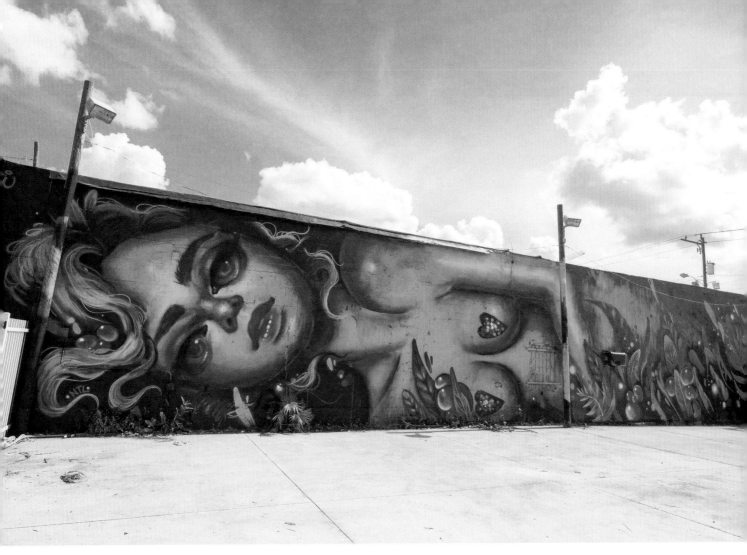

Mural, Miami, Florida, 2015.

El Salvador and Brazil Meet Miami

Born in Miami to an El Salvadoran father (who was also an artist) and a Brazilian mother, Suarez had a culturally rich upbringing, and it can be felt in the work she creates today. The subjects and context of her paintings often draw from myth and symbolism derived from her parents' heritages. Elements from these two countries, like local face paint, costume, and adornment, as well as the rich color palettes found in the South American tropics, echo throughout her imagery and choice of paint colors, bringing a hint of tropical life to the city streets she paints on. Her equatorial childhood and influence is also reflected in the overall tone of her paintings, which she describes as having an ethereal and airy quality. She's found that spray paint helps her achieve this look by using a sideways sweeping motion, allowing her to dust colors across large areas and enhance small details.

Caiubi, 2014. Spray paint and oil on wood.

On a more structured level, Suarez's approach to composition is heavily influenced not only by her parents' background but also by her studies in graphic design at the University of Miami. Her compositions fall within two distinct styles: fully painted canvases where color and imagery extend from edge to edge, and figures and background contained within a central graphic shape surrounded by a solid color. The women in her work are used to communicate various topics that range from personal history to themes related to pop culture and cultural belief systems, coupled with romantic imagery of flora and fauna familiar to the artist. The women in her pieces double as a means of activism for Suarez, allowing the self-described introvert to channel her fierceness through these fearless female forms as a voice to amplify personal expression.

This is Fine, 2014. Spray paint and oil on wood.

Mural, Sea Walls, Miami, Florida, 2014.

Mural, ArteSano, 2015.

Mural, SXSW, 2015.

The Primary Flight Push

The opportunity to transition from canvas to large-scale murals first presented itself in 2009 at Art Basel Miami, when the mural organization Primary Flight invited her to paint her first wall. Finding spray paint to be much more difficult to control than oil and brush, Suarez notes that her first attempts were somewhat daunting and discouraging, posing interruptions to her natural artistic process.

With Primary Flight's offer, she was forced to take the plunge and work through the challenges that learning any new medium will present. Making her first mural through the incredibly visible and heavily trafficked Art Basel Miami showed Suarez the exposure that mural painting could give to her art career. Inevitably her spray techniques evolved from blotchy marks, unnecessary sloppy lines, and brush-strokes into the sleek, controlled style she has become known in Miami for.

Like her strong, sexy characters, Suarez is one of the few women making waves on a roster of mostly male street artists. Aware of their obvious minority, Suarez and many other women on the scene support each other in both practice and creation, often sharing tricks of the trade. A collaborative mural with female artist Lauren YS pushed Suarez to paint a character entirely in spray, which strengthened her craft and enticed her to adopt spray as her medium of choice.

By embracing the art of spray paint, Suarez has become a part of the growing street art scene, opening up new opportunities, fans, and travel, simply because of the medium. Within the genre of mural and street art, Suarez found a new platform and audience that her studio work alone could not reach. On the streets, her large-scale murals have a presence that works in a gallery do not, playing roles in viewers' day-to-day lives, while also inviting new viewers and fans to explore her lush oils on canvas that she paints in her studio. She may use spray outside and oils on canvases, but the synchronicity of street and studio strengthen her message—and body of work—as a whole.

Suarez has been exhibiting her doe-eyed ladies since 2008 in gallery shows throughout Florida as well as in New York City, San Francisco, Los Angeles, Honolulu, and Detroit. She has also participated in numerous mural projects, including POW! WOW! in Kakaʻako, Hawaii, and Austin, Texas; the Heineken Pyramid at SCOPE in Miami, and PangeaSeed for Sea Walls in both San Diego and Isla Mujeres, Mexico.

CONOR HARRINGTON

HISTORY REMIXED – London, United Kingdom

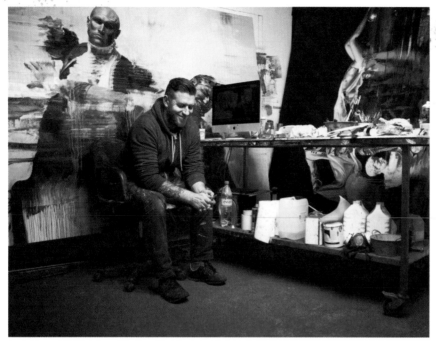

Portrait of the artist. Photo © Eoghan Brennan.

Conor Harrington's remarkable body of work is rife with metaphorical dichotomies, using historical references to confront the political and social issues of modernity. With an experienced past in graffiti, the London-based artist has used spray paint to create large-scale outdoor murals that bear the energetic movement of a graffiti writer, coupled with the detail of an Old Master. But spray plays more of a role than just medium. In the studio, Harrington apposes spray paint and oils, using their contrast to create a dialogue that weaves together present and past to address the rise and fall of global powers in the modern world.

FACTBOX

- Conor Harrington, Irish born and London based, has a celebrated gallery career with London's Lazarides Gallery.
- Harrington is known for his incredible fusion of historical and modern imagery, built up in many layers.
- The artist borrows from his experience in the graffiti scene to bring graffiti techniques to deeply historical and abstract portraiture, redefining the street art genre with fine art techniques and classical imagery.
- Harrington has nicknamed his study paintings "Morning Glories," because he gets to them first thing in the morning to catalyze his creative process.

www.conorharrington.com

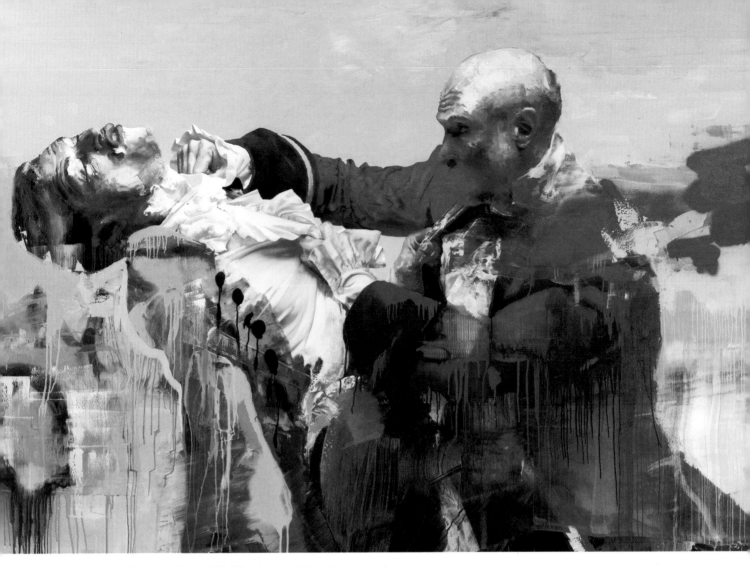

Breaking News and Opposing Views, 2015. Oil and spray paint on linen.

How on Earth Did We Get Here, 2015.
Oil and spray paint on linen.

Combining Genres and Styles to Make His Own

Harrington's conceptual understanding of the weight, meaning, and properties of different artistic mediums has helped him develop a recognizable style that creates cohesion from two mediums thought to be very different. The meshing of the two creates a beautiful visual style of balance, often using opposing genres, with oils rooted in centuries of traditional painting, and spray paint thought of in the utilitarian aspect (as well as the graffiti genre, which some facets of the fine art world are still slow to accept). He has perfected a style that puts one foot sturdily in each genre, taking a cue from academic painting mixed with a dose of the spontaneity of graffiti. A quick look at his body of work evokes hints of Baroque and Rococo portraiture, Abstract Expressionism, and 1980s graffiti writing, all harmoniously working together to resonate strongly with the viewer. This contrast is what attracted Harrington to the medium, and he uses spray paint as a tool to challenge the traditional mores of fine art.

Mugshot 7, 2015. Oil and spray paint on linen.

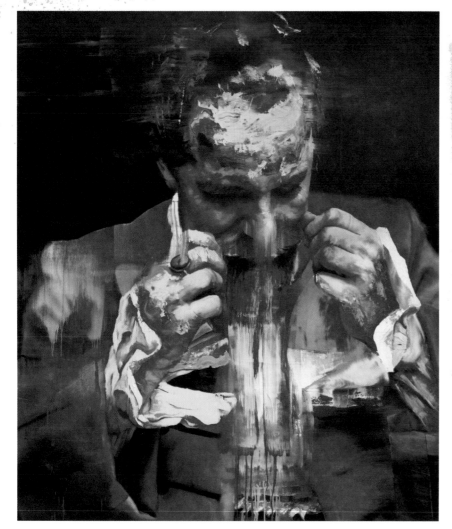

Repainting History

Harrington's compositions are a balance of tension and grace. With the hand of a master, he paints figures clad in what appear to be lush period costumes of aristocrats and rulers, pulled through time into the present. These characters bear elements of photorealism, with fine attention paid to rendering skin, plush fabrics, and facial detail. In fact, attention to detail is paramount. Harrington has been known to spend copious amounts of money to rent period furniture or costumes for reference. But each is also painted with an imperfection, a purposeful line of blur or a heavy-handed snag pulled from a science fiction movie. These appear as painted glitches, as if they were actually pulled through a fantastical time portal, the journey through the fabric of time evident with flaws akin to digital file errors. This reference to computer and digital imagery enhances his narrative, which uses historical figures to illustrate modern strife, comparing corrupted files to corrupted politics.

The models for the characters themselves are also often flawed, with clues given in the details of the costumes he paints. For example, rather than pulling from historical accuracy, Harrington has used historical reenactment enthusiasts and their garb as models, adding a layer of fabricated antiquity to his narrative. His usage of Regency-era costumes in other bodies of work is also meant to signify the historical shift away from the monarchy and the move to republics around the world, while checkerboard floors are a clear nod to seventeenth-century Dutch masters. This subtle cue is embellished further by juxtaposing graffiti style with historical painting.

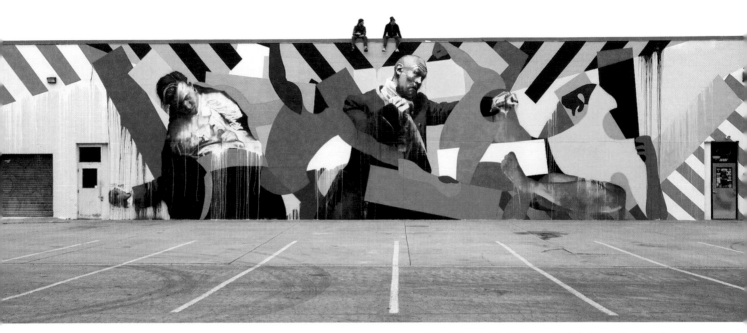

Using Spray to Confront Political Issues

Using a fine art approach to social and political issues gives Harrington's work more weight and palatability than graffiti and protest art, appealing to the discerning viewer with his use of sumptuous color and costume. Political art can often feel forced, unappreciated by the dispassionate—or heavily opinionated—viewer. By referencing the historical, he forces viewers to see a fresh perspective on global political issues, giving them a moment out of the familiar modernity to grasp issues that are oversaturated in the media.

Most of Harrington's characters appear stoic and strong, either seated in a traditional portrait or in action with one another, with movement implied and enhanced by his use of drips. When in the studio, the artist combines oils with spray and other media; outdoors, he has used spray for many years, and most recently turned to bucket paint for his murals. To push spray to its limits, Harrington likes to experiment with solvents to break down paint strokes. His signature drip effect, which transports his figures from the realm of the photo-realistic to the fantastical, is made by dousing the still-drying figures with cap cleaner, causing a controllable drip that adds a new dimensionality.

With a style of extremely detailed work, Harrington puts more focus on studio pieces, switching from spray to fine oils and small brushes to render control. Switching style from street to studio is an important concept for artists to comprehend when visualizing their own work, enabling them to have maximum impact. Although Harrington's work is ever changing, his continual dedication to referencing art historical and political imagery from the past has kept his body of work surprisingly fresh and modern, finding a comfortable middle point that viewers can not only relate to but also be enthralled by.

Harrington regularly shows with London's Lazarides Gallery. His murals can be found extensively throughout England, New York City, all over Europe, and in his home country of Ireland.

6

REALMS OF ABSTRACTION

Mural by Remi Rough, Posada Los Nogales, Spain, 2009.

Beyond the realm of representational art lies the power of simple shape and geometry. Artists working in linear and geometric shape explore worlds created with color and spatiality alone. Popularized by avant-garde artists in the early 1900s, geometric abstraction was initially a pushback against the modern representational painting of the time. Instead of making portraiture or landscape the center of the work, geometric abstraction refocuses the attention to the artist and art making.

Fundamentals of colors, line, and geometries are given center stage, as are paints, pencils, and other artistic mediums, all elements that require the hand and conceptual decisions of the artist.

Although geometric abstraction is not a new concept, it continues to be explored by artists, who test the limits of line and color. Now, with newer mediums and materials, geometric abstraction is given a fresh perspective. With the use of spray paint, artists are able to correlate modernity with the avant-garde of the past, relating color combinations from graffiti to illustrate and explore geometric landscapes, both in the studio and on a larger scale outdoors.

The artists in this chapter, Remi Rough, Will Hutnick, and Rubin, are informed by geometric abstraction of the art historical past, and use it as a starting point to reinterpret abstraction under each of their individual urban lenses. Londoner Remi Rough uses spray to fuse his interest in Graffuturism and geometry, often infusing geometric colorscapes into urban settings. Will Hutnick uses spray to combine spontaneity with controlled edits, embracing the power unleashed when a nozzle is depressed. Born in Sweden, Rubin uses his Scandinavian design sensibilities to reinterpret Wildstyle graffiti, resulting in colorful, geometric combinations that can be found all over the world.

DIY

Painting Easy Abstract Shapes and Patterns with Caroline Caldwell

Creating geometric abstraction with spray paint can be done either freehanded or by using a variety of tools to make sharp lines and shapes. Use primary colors for a throwback to Piet Mondrian or contrasting hues to create a vibrating edge effect. Artist Caroline Caldwell paints one of her signature assemblage houses to show myriad abstract techniques to use on your own pieces.

About the Artist

A recent graduate of Sarah Lawrence College, Caroline Caldwell is a young illustrator, painter, and writer based in Brooklyn, New York. Caldwell's personal work deals with themes of home, death, and rebellion. Her work questions ideas of property, through both surreal architectural illustrations and interventions in public space. She is also a regular contributor to the popular street art blog *Vandalog*, and has worked as a studio assistant to notable artist group Faile and Jeremyville.

1

About the Project

This project explores several different techniques that could be used for an abstract piece. Caldwell walks through some easy tricks, including making different patterns with tape, exploring positive and negative space, using cardboard for hard edges, and using household objects like string to make other patterns. Practice with just one of these techniques or combine them for a cohesive piece in a collage of all of the different techniques.

1. Start by adding a colorful background. Try adding simple blocks of color. Create a second color fade to your background by using a fat cap. Holding the can farther away from the canvas, tilt the can and lighten your pressure on the cap as you sweep back and forth.

2. Use painter's tape on your dry background to create patterns. Using an X-Acto knife, cut a roll of painter's tape in half to get two stacks of equal-sized tape rectangles. Lay out these tape pieces for a pattern that plays with negative space.

3. Spray over the tape evenly in a back-and-forth motion. When the paint is dry, carefully remove the tape to reveal the pattern.

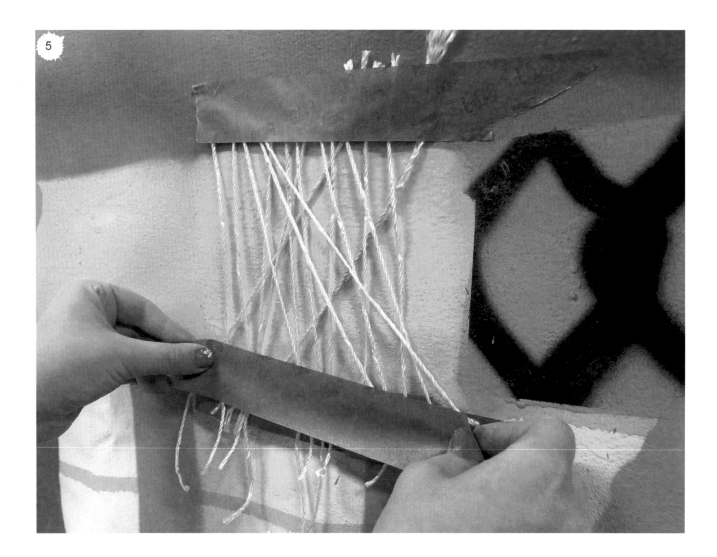

4. Make a checkerboard by laying the tape in straight, even lines vertically and horizontally. Space each row the same width as the tape. Spray over this and remove the tape. Make sure the paint is fully dry before the next step. Using the same process, layer the tape in straight even lines over the rows of squares you just made. Spray and remove the tape when dry.

5. Use household materials such as string or mesh to add interesting textures. Spray lightly to get more detail.

6. Carefully arranged painter's tape can also be used to emulate bricks.

7. Arrange diagonally and spray with a contrasting color.

8. Practice freehand lines to create abstract and geometric shapes. To get thinner lines, press lightly on the nozzle and aim the stream of paint more toward the cardboard so that only a small portion hits the intended area.

9. Cardboard can be used to create sharp edges and final details. You can also use cardboard as a shield when doing fades to create dimension.

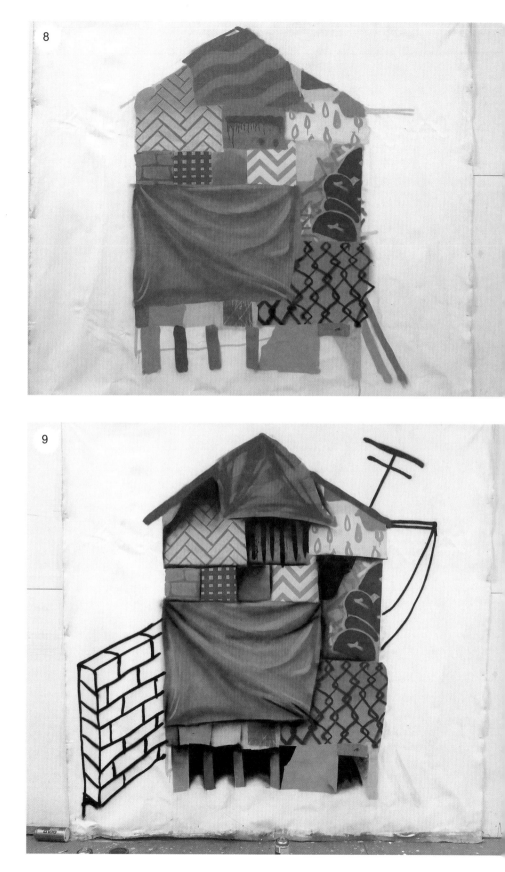

REMI ROUGH

GEOMETRY AND GRAFFUTURISM — London, United Kingdom

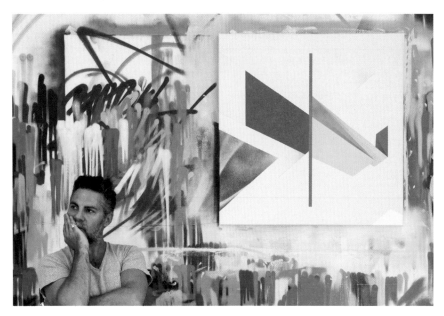

Portrait of the artist, 2015. Photo © Michelle Morgan.

London artist Remi Rough's distinctive style pushes abstract geometry into the realm of urban art. Belonging to the school of Graffuturism, which rests on the foundations of graffiti art and geometric Suprematism, Rough transforms both canvas and large-scale walls into colorful angular landscapes that leap off of the picture plane. Controlling spray-painted fields of color with tape, Rough creates shapes and form that push and pull linear line, redefining post-painterly abstraction.

FACTBOX

- Based in London, Remi Rough is part of the Graffuturism movement, which seeks to transcend the chaos of graffiti with elements of geometry.
- The artist uses tape and spray paint to create crisp lines in his geometric planes and abstractions.
- He was introduced to spray paint in the 1980s after seeing a copy of the book *Subway Art* by Martha Cooper and Henry Chalfant.
- Rough started out by mastering letters perfectly before moving on to abstract and geometric shapes.
- He painted London's largest mural with Steve More, LX One, and Augustine Kofie in 2012.

www.RemiRough.com

Megaro Project, Agents of Change, London, 2012.

The Graffiti Road

Rough's reinterpretation of geometric abstract art arrived after a long journey through traditional graffiti. Before the luxury of discovering trends on the Internet, Rough was first introduced to graffiti style as a teenager in 1984, when a friend had a copy of Martha Cooper and Henry Chalfant's iconic book, *Subway Art.* Transfixed with the Wildstyle graffiti portrayed in the book, he obsessively copied images from it over and over in a notebook with pen and pencil. Moving on to spray paint was a process, with only automotive paint available at the time. With no mentor, Rough relied on teaching himself to control the can, practicing through trial and error for a year and a half before feeling truly confident.

For Rough, graffiti wasn't about tagging his name in as many places as possible, but instead about precision. He spent his youth mastering the use of spray paint to render letters perfectly, to make perfect lines, and to fade colors as if they were manipulated digitally. Getting into graffiti in the mid-1980s before there was a bevy of spray paint varieties available also gave Rough a unique understanding of how to mix and fade, a silver lining to only having industrial paints in limited colors available. He attributed his understanding of color to fellow graffiti artist Juice 126, an innovator whom he met at the graffiti World Championships in Bridlington, United Kingdom.

> I think spray paint helps you push through and find new directions to take the work in. There are certain things that I use within making my work that I just wouldn't be able to achieve with acrylic or oil—getting really thin, perfect lines with masking tape, for example.

Neon Neon, 2014. Mixed media on wood.

Graffiti to Architecture and Abstraction

Gradually, his experience with writing graffiti matured into an intense interest in abstraction, the spray paint skills he honed in graffiti seamlessly transferring to his focus on line, geometry, and color. His inspirations from Graffuturist writers Dondi and Futura, who were known for creating the first abstract graffiti pieces in the early '80s, were soon joined by Constructivists and abstract painters, like Piet Mondrian, Kazimir Malevich, Cy Twombly, and architect Zaha Hadid. When Rough started to use tape to refine lines, his perspective on clean lines and sharp edges was heightened, pushing his work in an even more abstract direction. Using tape, Rough can achieve perfect forms with clean lines. With these pristine lines, Rough was able to play with tension and movement of shape, focusing on what he was painting instead of how he was painting it.

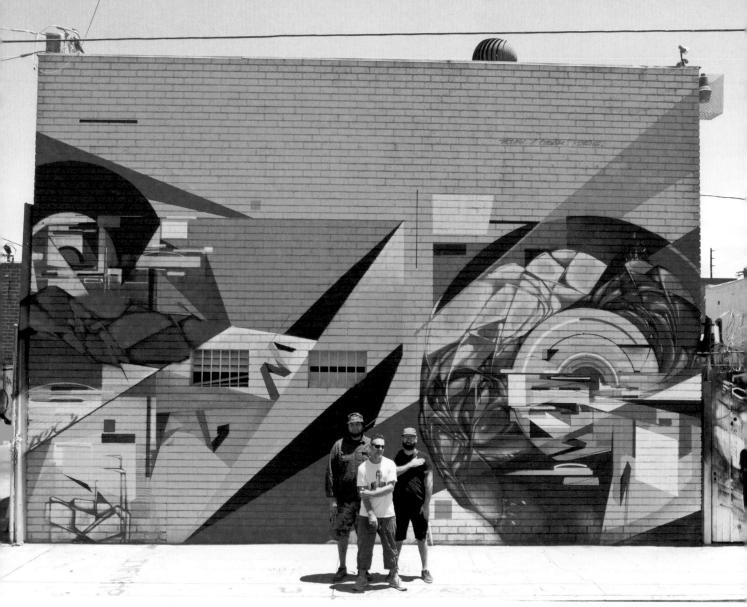

Collaboration with Augustine Kofie and Codak, Los Angeles, 2014.

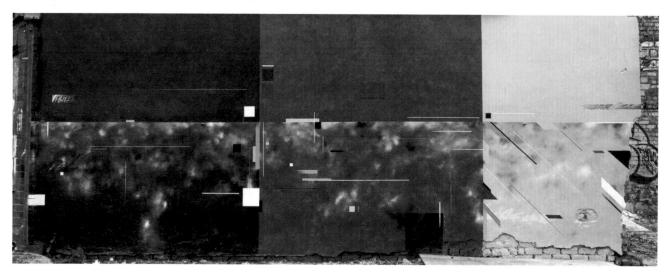

Mural, Belfast, Ireland, 2012.

Excavated, 2014. Spray paint, graphite, and ink on handmade paper.

Defencer, 2015. Spray paint and graphite on handmade paper.

Compression, 2015. Spray paint, graphite, and ink on handmade paper.

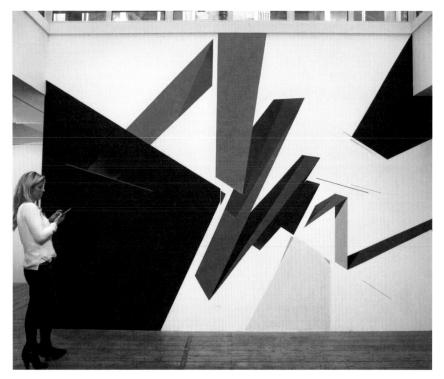

Gallery Installation, Scream London, 2015.

COLOR, LINE, AND MOVEMENT

Following the vein of abstraction, Rough has amassed a body of work both large scale on the street and in the studio on canvas, paper, and wood. With the influx of more colors and qualities of spray paint in recent years, he is able to continue experimenting with the relationships among color, line, and perceived movement. On paper or wood, Rough's artworks have an ageless quality not anchored in any time frame, feeling both modern and as if lifted from an exhibition on the De Stijl or the Bauhaus movement, using spray paint, acrylic, pencil, and ink. But outdoors, Rough's large-scale geometric works are read with an impact on their environment.

The roving lines and unexpected encounters in color have transformative properties that create an implied movement and force on the architectural facades on which they are painted. A seeming explosion of color and line, Rough's murals play with their surrounding architectural lines, confronting and surprising passers-by with their sleek geometry and disorienting movement.

Rough regularly exhibits his interpretation of abstract art in gallery shows around the world. His comingling of street art and geometric abstraction has made his outdoor murals a welcome environmental interruption in varying landscapes. Along with artists Steve More, LX One, and Augustine Kofie, he painted London's largest mural in 2012, on the facade of the Megaro Hotel. His murals can also be found interacting with the local architecture in Gambia; Saint-Jean-de-Luz, France; London; Krakow; and beyond. A complete survey of his work from 1984 to the present was published in a monograph in 2016.

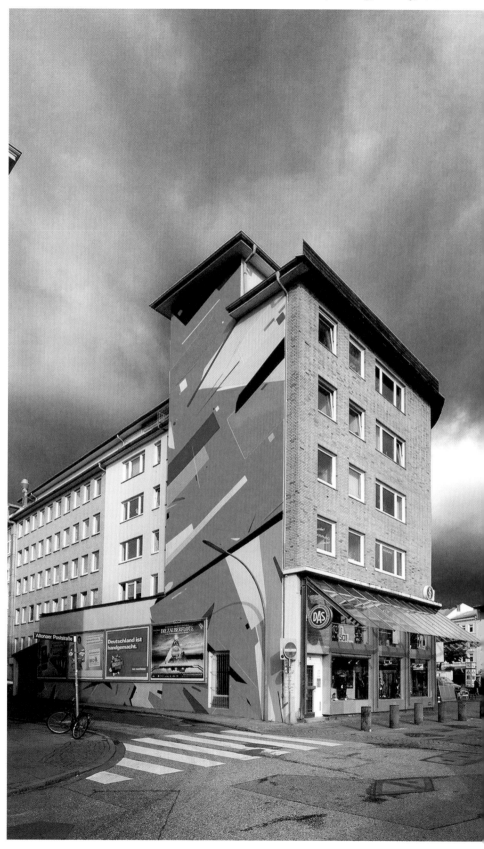

WILL HUTNICK

SHAPES IN MOTION — Wassaic, New York

The artist in front of *Time Machine*, 2015.

For Will Hutnick, painting is a series of sporadic cycles, in which the artist may paint elements quickly, spend hours on one layer, or revisit older works at any given time. The former Brooklynite is now working in upstate New York, where he is the residency director for the Wassaic Project, a 501c3 nonprofit organization that provides a genuine and intimate context for art making, strengthening the local community by increasing social and cultural capital through inspiration, promotion, and the creation of contemporary visual and performing art. As a creator, Hutnick allows mixed media to dictate the direction a painting takes. In a process of spontaneous bursts, followed by controlled editing, the artist seems to tame the beast within with his art making. Playing on his chaotic side, Hutnick uses spray as an anarchic presence that represents a moment of unbridled freedom, further controlled by creating hard edges and shapes with the aid of tape. The resulting pieces are an abstraction of color and form that play with dimensionality, often taking on amorphous qualities with contrasting textures.

FACTBOX

- Will Hutnick left his studio in Brooklyn, New York, to become the residency director for the Wassaic Project in Upstate New York.
- He was first turned on to spray paint after observing the colorful murals in his neighborhood in Brooklyn.
- The artist uses spray in his abstract pieces as a spontaneous, anarchic presence.
- Hutnick often works on many paintings at once, believing that the relationship between materials should dictate the direction his pieces take.
- He loves spray paint for the hazy and glowing quality that creates atmosphere within his works.

www.willhutnick.com

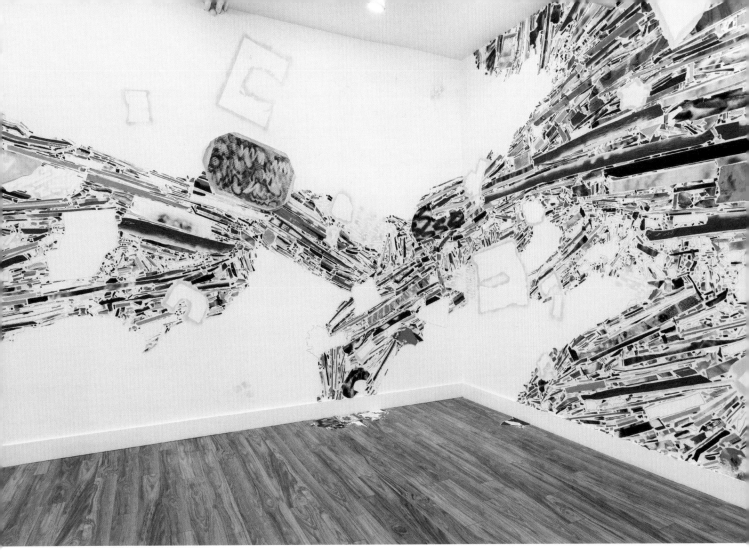

YOU'RE A GHOST, 2015. Acrylic, paint marker, paper, spray paint, tape, and Tyvek for the Java Project.

A Dialogue Between Materials

The relationships among materials, technique, and shape are constantly in flux and interplay in Hutnick's paintings, inspiring each piece as the artist's process unfolds. By relating materials such as repurposed collage, acrylic, marker, and spray paint, Hutnick creates a dialogue between each step of his art-making process, which is evident to the viewer in the final paintings.

These moments of creation vary from contemplative and calculated, textural paintings with fields of acrylic, to quick and aggressive mark-making with spray paint. The resulting impressions and surfaces from the latter are then fine-tuned and controlled.

Gentle Hour, 2015. Acrylic, paint marker, and spray paint on canvas.

Journal Party, 2014. Acrylic, paint marker, paper, spray paint, stickers, tape, and Tyvek on paper.

Afghan Journal, 2014. Acrylic, paper, spray paint, stickers, and tape on paper.

Bringing the Artist's Hand into the Work

Trained formally at Providence College and then at Pratt Institute for his MFA in painting, Hutnick did not introduce spray paint into his process until 2009, perhaps subconsciously due to living and working in Brooklyn, where spray-painted murals are prevalent from block to block. The first presence of spray paint came when Hutnick was experimenting in making paintings outside of traditional means, shirking brushes and palette knives, thus removing the "artist's hand" from the process. With spray paint, Hutnick was able to bring the artist's hand back into the work, in an indirect yet representative way. Working with spray paint had an immediate and direct action, which he would employ with various paintings and projects at once.

Hutnick's interest in the evolution of artwork extends beyond his process and into the life of his paintings.

Coinciding with his interest in the beauty of the natural states of decay, Hutnick is intrigued by the lack of archival properties that utilitarian spray paint has, embracing the changes caused by time.

> "When I see spray paint start to crack on the surface over a period of time, it makes me smile because the work has this other life that I'm not a part of, that I'm just witnessing."

Hutnick is a multidisciplined professional, heavily steeped in the art world as both a prolific curator and a practicing artist. He has shown both paintings and sculptural installations extensively throughout New York, Philadelphia, Dallas, Las Vegas, and Barranquilla, Colombia. He has also held artist residencies at Yaddo (Saratoga Springs, NY), The Wassaic Project (Wassaic, NY), Vermont Studio Center (Johnson, VT), and through 4heads on Governors Island (Governors Island, NY), and he is the curator in residence at Trestle Projects (Brooklyn, NY). He is a member of the artist-run collective and exhibition space Ortega y Gasset Projects in Brooklyn, and is currently the residency director at the Wassaic Project.

Trade Show, 2015. Acrylic, paint marker, and spray paint on canvas.

RUBIN415

ABSTRACTIONS AND SCANDINAVIAN DESIGN – Brooklyn, New York

Portrait of the artist in front of his mural, Brooklyn, New York, 2014.

FACTBOX

- Artist Rubin415 was raised in Gothenburg, Sweden, by Finnish parents before moving to New York.
- The starkness of his childhood home—a concrete housing project—inspired him to pick up a spray paint can at age nine.
- Unlike other geometric artists, Rubin415 does not use any tape or projections to make his abstract pieces.
- The artist often sketches directly onto a photograph of the wall he is to paint to get the correct proportions.
- Rubin415 sees his geometric pieces as a mesh of graffiti and Scandinavian design sensibility.

www.rubin415.com

All Rubin415 ever wanted to do was to paint murals in New York City. The artist first picked up a can of spray paint at age nine, with a mission to add color and life to his drab concrete housing project in Gothenburg, Sweden. Working exclusively outdoors for many years, Rubin415 was first influenced by the seminal graffiti film *Beat Street*, which was released in 1985. His work has since evolved, fusing the clean lines of his Scandinavian heritage with the traditional graffiti he grew to love, to create his own version of Wildstyle, seen through a geometric lens.

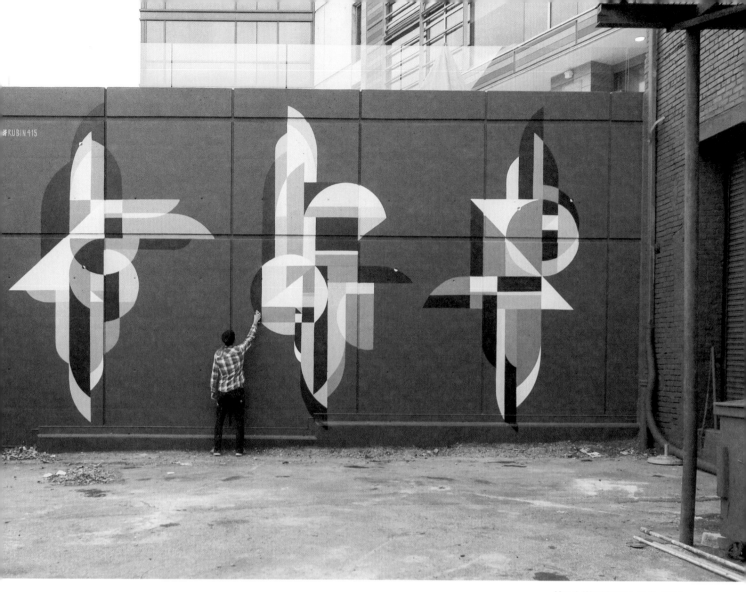

The Drab Concrete of Bergsjön

Growing up among the mundane concrete of the Bergsjön housing projects (the "415" comes from the local zip code) in Gothenburg, Sweden, Rubin415 picked up on the immediacy of spray paint around the same time other kids were still playing with Matchbox cars and army men. With his housing project as his canvas (to the disdain of his parents), the artist ventured on a journey of self-expression, teaching himself the art of spray paint through years of trial and error.

Moving to New York to paint was Rubin415's dream, and since relocating he has left his mark on the city by becoming as prolific as possible. In New York, his style evolved from spraying letters to his recognizable abstract geometry, deconstructing traditional graffiti letters into abstracted shapes that are meshed with the simple, minimalism of Scandinavian design. Translating the bold colors of graffiti with Scandinavian aesthetics, Rubin415 has purposely muted his color palette to make consistency in his recognizable style. Although he works from sketches, he chooses his colors on the spot and by instinct, allowing the environment to dictate which colors make sense for that location.

Mural, Denver, Colorado, 2015.

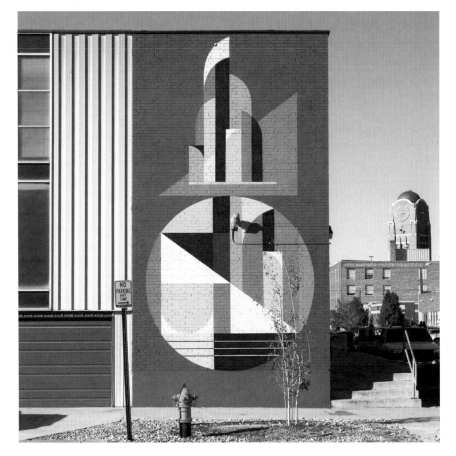

"Creating something that will last felt important to me, as a vast majority of my work doesn't exist anymore. There are so many different kinds and brands of spray paint and you have to do your research. The same way you shouldn't use acrylics over oil, you have to know which spray paint brands don't work well together. I never use spray paint with cheap pigments in my studio works; that way, I don't have to be concerned about the archivability."

Rubin415's sketch process is also interesting in itself. Rather than making sketches on plain paper and then scaling to an outdoor wall, the artist sketches directly onto photographs. Because he works without projectors, stencils, or tape, he has developed a process of rough sketching onto photographs of the actual commissioned spaces and walls as a way to not only ensure perfect proportions but to also help him envision the completed piece. This analog way of sketching also allows Rubin415 to play with the architectural details of a space with more freedom, making pencil sketches that interact directly with windows, doorframes, and corners.

Although sketching on photos helps his creation process, the artist likes to spend time on the site previous to painting, allowing the architectural nuances to influence how a piece develops. Understanding his outdoor canvas is coupled with his years of working with spray, which allows Rubin415 to paint with the confidence of a veteran, where some spontaneity can infuse the creative process on site.

From Street to Studio

To Rubin415, creating art comes naturally, but transitioning from street to studio was perhaps the biggest challenge in his career. On the street, he is able to paint somewhat autonomously, with the ephemerality of a street piece having great influence over how his work is made. Although his murals are beloved, they could be painted over any day, adding an element of excitement and immediacy. But transitioning to studio work forced the artist to reconsider his approach, trading the noisy chaos of painting on the street for the quiet solitude of the studio. Considering permanence also forced the artist to reconsider his materials, adopting acrylics and resin, as well as looking at spray paint from a different perspective.

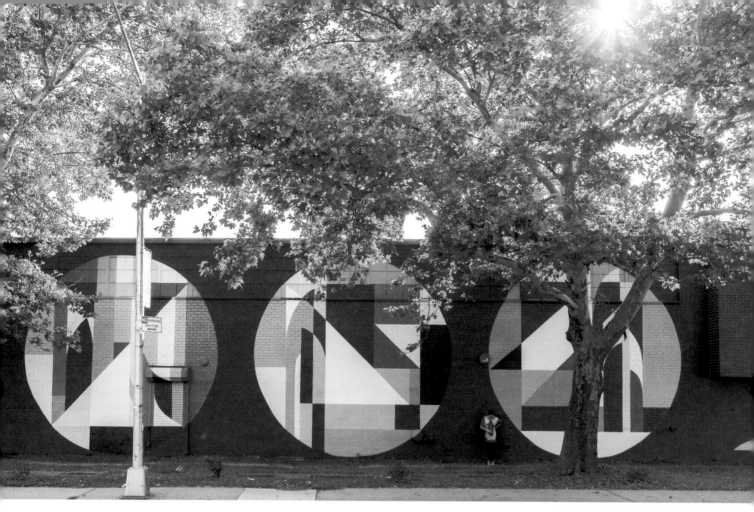

Mural, Brooklyn, New York, 2014.

Geometric Timelessness

In the studio, Rubin415's works take on a timeless appeal, their smaller scale creating a dialogue with art historical works by artists like Francis Picabia, Robert Delaunay, Jean Metzinger, and others experimenting in Cubism and geometric abstraction. Painting on wood panels and using resin to create a glossed and sealed surface gives his studio works a separate identity than his works on the street, allowing the two to be recognized distinctly as Rubin415, but illustrating the artist's understanding of creating art for different and appropriate venues.

Rubin415's work can be found across the five boroughs of his adopted New York City both indoors and out, as well as on concrete and brick in Thailand, his native Sweden, and across Europe. His studio work has been shown in New York, Stockholm, Reykjavik, and Montreal, and in 2016 in solo exhibitions at WallWorks Gallery in New York and at C.A.V.E. Gallery in Los Angeles. His first comprehensive art book featuring his work was released in 2016.

Xxx, 2015. Spray paint on wood.

7

IN THE MIX (MIXED MEDIA)

Bra [detail] by Dana Oldfather, 2015.
Oil, ink, and spray paint on linen.

Even artists not committed to working in spray paint alone have found useful and diverse applications for it in their mixed media. As stated before, spray paint's sleek and textureless quality is attractive to artists working in oils and other mediums, and as an alternative to washes, watercolors, and mists. These artists incorporate spray into their routine to introduce atmospheric layers, contrasts of soft or heavy markings, or even stencil elements to their pieces.

In some ways, these artists show the true diversity of spray paint, manipulating and adapting the spray can for their mixed media styles. With mixed media, the artists must not only consider the properties and limitations of spray paint, but also the way that spray interacts physically, chemically, and visually with their other materials.

Structural engineer and artist Zac Braun uses the autonomy of spray to inflict an art-making methodology onto himself, savoring the process as much as his abstract paintings. Ian Kuali'i uses spray as an underpainting for his intricate paper-cut works, in effect creating whole paintings that only the artist himself will see in their entirety. British artist Ele Pack uses spray to create gauzy, ethereal fields, which are interspersed with oils, acrylics, and spray-painted stenciled elements, and finally Dana Oldfather uses spray to create a contrast between cottony color fields and bold brushstrokes that show the artist's hand.

DIY

Painting Traditional Backgrounds with Neon Lighting Effects with Rebecca Paul

Incorporating spray paint into mixed-media works can add bold colors without unwanted texture. Painter Rebecca Paul uses brightly colored spray paint to create an enigmatic lighting effect behind a chiaroscuro portrait, adding an illuminating contrast to her black, white, and gray portraits. Since spray is applied with no texture, Paul is able to build up atmospheric color without affecting the surface of her figure.

About the Artist

Rebecca Paul is a painter and installation artist from New York and is currently living and working in Berlin, Germany. After several years focusing on green and sustainable design and architecture, Paul is now exploring her own artistic voice within Berlin's vibrant art scene, focusing on mixed-media portraiture and figurative works.

About the Project

Traditional portrait painting methods recommend that the background be painted in conjunction with the main subject. However, when using spray paint a bit more planning is involved, and decisions on color and value need to be established early on. These decisions should consider what's best for both the subject and the surroundings. Incorporating spray paint into this process allows you to introduce bolder, more vibrant hues not easily achieved working solely from the tube. Neon spray paint colors can immediately draw the eye and make for a modern approach to the classic methods that are normally represented with neutral browns and grays.

1. Select a surface to work on. You can use a canvas, or if you're looking for something more cost-effective you can repurpose any piece of wood or cardboard. Prep the surface with the first layer of gesso by mixing three parts gesso and one part water together. Use a large brush to cover the surface with a thick layer of your water-gesso mixture.

2. Select two base colors for your background; one should be light and the other very dark (black is always a good option). With the dark color, roughly lay down what will be the darkest areas of your final piece. Do the same with the other color, but focus on lighter areas instead.

3. Apply another light layer of your water-gesso mixture, allowing it to create drip marks if desired.

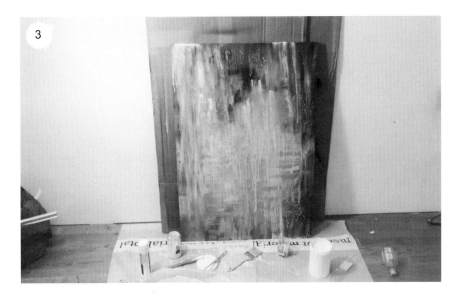

4. Either using a grid or drawing freehand, use a pencil to outline the areas of your composition that you want separate from the background.

5. Use scrap paper and tape to mask this area, prepping it for your second layer of spray paint.

6. After the area is masked out, select one neon color you want to use to represent your light source and two additional contrasting shades (one should be light and the other dark). When selecting your colors, consider tones that you plan to use as accents for the central image. This will help create a consistent color theme throughout the composition. Spray your canvas following the dark and light guidelines defined in step 2, but keep the neon tone for the brightest areas only. This will help create a colorful glow behind your image. After you've sprayed your background, remove the tape and paper used to mask out your central image.

7. Use black paint to carefully trace over any pencil marks used to draw your central image. After your outlines are defined, use gel medium mixed with black paint to fill in the shadow areas of your picture.

8. Continue to refine your painting using layers of the gel medium and black paint mixture, alternating white gesso for the light areas and black for the shadows. Use this process to establish a well-defined underpainting. After you've achieved your desired level of rendering, use the same gel medium layering process but replace black with color.

9. Use blacks and white to fine-tune your portrait, which will contrast with your neon background.

ZAC BRAUN

LETTER AND STRUCTURE — Rochester, New York

Portrait of the artist. Photo © Kelli Foster, 2016.

FACTBOX

- Based in Rochester, New York, after years in New York City, Zac Braun works as a structural engineer by day and a painter by night.
- Braun was on the structural engineer team that designed New York City's High Line Park.
- The artist's work focuses more on his own methodological process rather than the resulting painting.
- The artist turned to spray paint as a way to disrupt his process and to challenge himself with its unpredictability.
- He now uses spray paint to create repetitive forms and structures through hand-cut stencils.

www.zacbraun.com

As a structural engineer, Zac Braun has an approach to art that is somewhat unorthodox. Braun takes solace in his self-imposed methodological process, finding his creativity in art making, rather than in his final paintings. Braun's process includes the reevaluation of each medium's intended purpose, pushing materials like spray paint to perform in new ways by manipulating the contents of the can. Inspired by numbers, repetition, and structure, Braun creates minimalist works that are fine and textured, accentuating form in mostly monochrome. Despite the artist's interest in the creation process, his multimedia works bring the viewer the silent comfort of organized order.

Paint or the Painter, 2004. Spray paint and acrylic on paper.

Spray Paint, Acrylic, Folded Canvas, and Found Material

Based in Brooklyn, Buffalo, and Rochester, Braun works 9:00 to 5:00 as a structural engineer, and this is directly reflected in his artwork. Informed by industrial techniques and materials, he approaches artistic mediums from an analytical perspective, focusing on form and structural properties. Strands of disused of VHS cassettes become meticulously ordered glossy lines; the canvas picture plane becomes a surface meant for folding and building up three-dimensional form; acrylic paint is built up in texture and layered repeatedly to create the perfect crust. Each material has its specific process that engages Braun's senses.

Since Braun's work focuses so much on process, the artist relies mainly on black, white, and gray to illustrate his expressions. Letters and numbers play a large role in his compositions, and are used for their angles and line rather than their representative nature. Layering the letters is often combined with folding the canvas, causing a purposeful double-layering effect between the surface of the canvas and the surface of the artwork as a whole.

Disrupting His Process with Spray Paint

After mastering his manipulation of predictable materials like canvas and acrylic paint, Braun turned to spray paint as a means to intentionally disrupt his methodical practice and force himself outside of his normal scope. The unpredictability of spray paint created a new challenge that threw a wrench in the comfort of the calculated properties of other materials. Adding in the element of gas-pressured paint enabled new processes, techniques, and rules, creating a new problem to unravel and solve to Braun's satisfaction.

In addition to the excitement of this "game of chance," Braun finds a thrill in pushing spray paint to do the opposite of its intended use. In the same vein of his motivation to create solely for the purpose of process, spray paint gave Braun the chance to allow his work to delve into the conceptual realm. By challenging the medium's intended process, he calls into question the importance and meaning of intention.

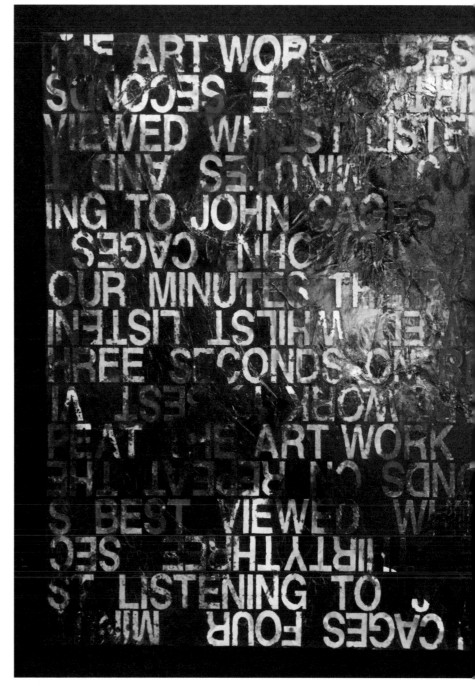

Untitled (Cage Cover Up 01), 2015. Spray paint and mixed media on canvas.

"I first used cheap spray paint with inexpensive tops in the complete opposite way of what it was meant for—I "dribbled" rather than sprayed, and when I did that it created a really beautiful effect into an extremely diluted (with water) solution of acrylic paint. Spray was designed as paint for quick coverage for vast areas. I used it by negating this purpose: I held the top valve mechanism ever so slightly so it coagulated and "bottle necked," then held it over a flat "laying" surface (as opposed to a wall) to make it dribble rather than cover. I spray, but then I am at the mercy of not only my process but also the paint's process of navigating what it was not initially designed to do."

Untitled (Cage Cover Up 01) [detail], 2015. Spray paint and mixed media on canvas.

Jon Triptych (3) [detail], 2014. Spray paint, acrylic, and paper on panel.

Braun's focus on process gives viewers an opportunity to rethink their idea of what a comfort zone is, and an excuse to reevaluate the familiar elements in their day-to-day lives. His minimalist artworks are widely accepted and respected by the fine art forum, but their means of creation inspire the supposed "unartistic" to try their hand at art making, with the satisfaction of process giving them not much to lose.

Braun currently works at an engineering firm in Buffalo, New York, designing buildings in the tri-state area, while continuing his artistic process fascination at night in his studio in Rochester, New York. His artworks have been shown in group shows in New York, Miami, Philadelphia, London, and Hamburg.

A

B

C

D

A *Untitled (Wrinkle 03)*, 2010. Spray paint, paper, and graphite on panel.

B *Untitled (Wrinkle 04)*, 2010. Spray paint, paper, and graphite on panel.

C *Untitled (Wrinkle 01)*, 2010. Spray paint, paper, and graphite on panel.

D *Untitled (Wrinkle 02)*, 2010. Spray paint, paper, and graphite on panel.

IAN KUALI'I

PAPER AND SPRAY — Berkeley, California

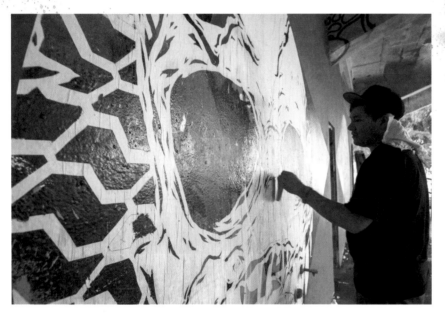

Miami Marine Stadium progress shot, 2014. Photo © Logan Hicks.

Factbox

- Ian Kuali'i apprenticed with legendary Rock Steady Crew artist Doze Green for seven years.
- He started out painting graffiti in Santa Ana, California, spent ten years in New York, and now lives in the San Francisco area.
- Learning from mentors instead of formal schooling, Kuali'I has integrated his graffiti background with fine paper-cut art, creating mixed media color fields that his paper cuts sit atop.
- Much of his spray-painted work is seen by the artist's eyes only.
- Kuali'i is interested in exploring his Hawaiian and Native American ancestry with his work.

www.iankualii.com

Artist Ian Kuali'i's paper-cut paintings are a personal dichotomy, unifying the delicate and the rough in symbiotic pieces that combine chaotic spray paint with pristine hand-cut paper. Layers of aggressive markings made with spray paint are coaxed and controlled beneath the opacity of cut paper, peaking out in the colorful vignettes of negative space revealed by the artist. Part of Kuali'i's work has a surreptitious quality seen only by the artist himself, with much of his work forever obscured from the viewer by a figurative layer of paper on the artwork's surface. With paper and mixed media, Kuali'i creates deeply personal works, using spray paint to engage in a dialogue with his graffiti past.

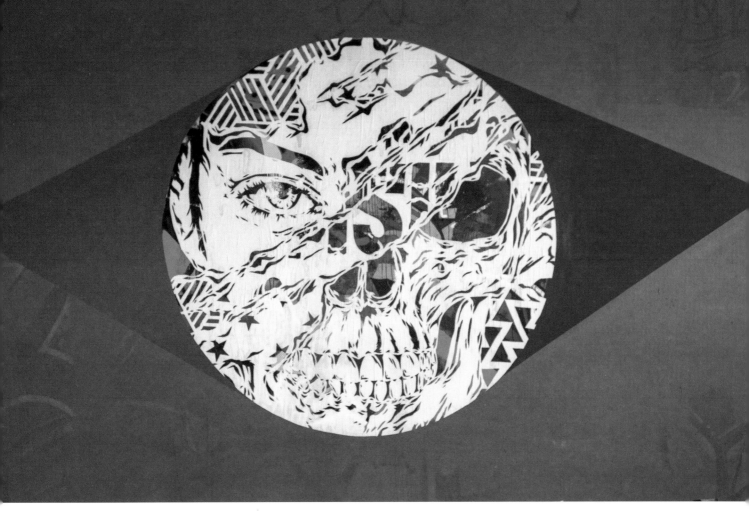

Fragments 1, Hand-cut paper and spray paint mural at the Miami Marine Stadium, 2014. Photo © Logan Hicks.

Learning Under Doze Green

Growing up between Orange County, California, and Maui, Hawaii, Kuali'i was introduced to spray paint early on, as the cultural evolution of hip hop in the 1980s and '90s hit the West Coast. Beginnings in graffiti helped the self-described "angry teenager" let off some of his adolescent angst, and he spent hours painting along the train tracks on the border of Orange and Santa Ana, California, in a place called Hart/Santiago parks. Painting with spray became Kuali'i's therapy, and he carried it into his adult life when he began pursuing his artwork seriously. Rather than formal art schooling, Kuali'i sought out mentors to teach him styles, tricks of the trade, and control of the can. The self-taught artist perfected and honed his skills and creative vision under the mentorship of legendary graffiti artist Doze Green, whom he apprenticed with for seven years. It was under Green that Kuali'i developed his signature style of blending paper-cut portraits, figures, and lacelike forms with heavily painted underlayers, using spray to create bold and colorful abstractions.

Nunc Evanescunt, 2015. Hand-cut paper, spray paint, and acrylic on wood panel

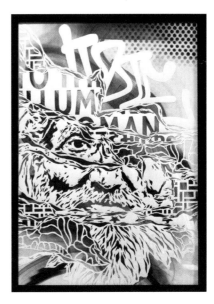

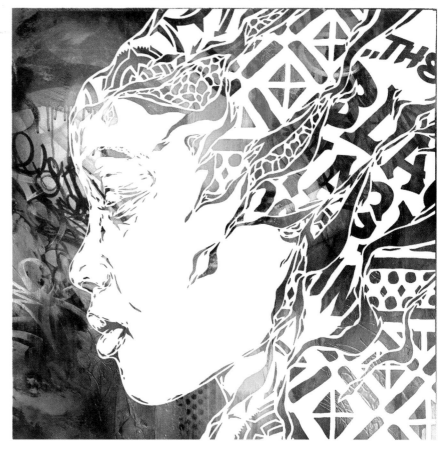

Black Magic, 2015. Hand-cut paper, spray paint, and acrylic on wood panel.

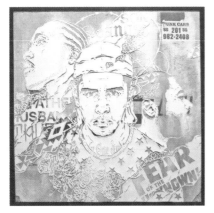

For They Know Not What They Do / Those Who Don't, 2015. Hand-cut paper, spray paint, and acrylic on wood panel.

Now living in Berkeley, California, with his wife and daughter after many years in the New York City area, Kuali'i sees his work and process as a metaphor for the evolution of his work and life. His multiple processes bring his personal history together in a cohesive style that delves into his past, paying tribute to different facets of his life. His time in New York is reflected in the textures of his underpaintings, which resemble the familiar weathered surfaces found in urban settings; inspiration from vandalized buildings, wheat-pasted advertisements, and commercial signage can be seen when examining the color fields on the lower layers of his works. On one hand, Kuali'i's style is informed by his past in graffiti, but on the other it embraces the tradition of the delicately tactile and meticulous process of working with paper. Graffiti is chaotic and freehanded; a mispainted line can simply be covered over and over again until it is perfect. But cutting paper is unforgiving, requiring precision and patience. Both facets require the artist to tame two sides of his creativity, while forcing them to work together.

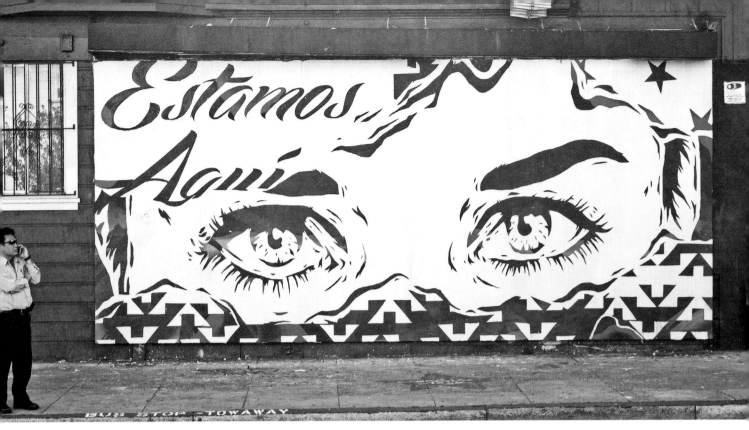

Estamos Aqui, **Galeria de la Raza, San Francisco, California, 2014.
Hand-cut paper and spray paint on street-level billboard.**

The Action of Spray Paint and the Calm of Cut Paper

Kuali'i's process begins with the raw action of spraying aerosol paint. With spray, the artist is able to create multiple layers of color, line, and shape, without building up texture, which ensures a smooth surface for the paper layers to rest on. Although these underpaintings are only shown in the negative space between his paper cuts, their richness, complexity, and atmospheric layering can still be experience in the snippets that are revealed. Once the detailed hand-cut paper pieces are affixed to a painting's surface, Kuali'i may go in with acrylics or other media to add textural embellishments.

These two seemingly different processes also reflect Kuali'i's interest in his family heritage, balancing his self-identification as a New Yorker/city dweller with his ancestral ties to the indigenous people of the Southwest United States and Hawaii. With this balance, Kuali'i illustrates imagery influenced by mythology, spirituality, empowering portraiture, and mortality.

While mostly working on wood in the studio, Kuali'I uses spray paint and paper on outdoor and indoor walls, pushing his work to the large scale, most notably in New York City and in the Miami Marine Stadium. In 2014, Kuali'i held his first artist fellows residency at the de Young museum in San Francisco, California. His second artist residency was in 2016 at the Red Bull House of Art in Detroit, and was curated by Matt Eaton, who is also featured in this book. Kuali'i's paper-cut and spray-painted pieces have been shown extensively in New York, as well as Miami, San Francisco, Germany, Switzerland, and his native Hawaii.

ELE PACK

ETHEREAL EMOTION — Brighton, United Kingdom

The artist in her studio, 2016.

FACTBOX

- Based in Brighton, UK, Ele Pack received her degree from Loughborough College of Art.
- She uses spray paint to create ethereal and gauzy layers in her abstract works.
- Inspired by organic shapes in nature, Pack creates her own stencils to repeat these shapes in her paintings.
- The artist began using spray paint when seeking an alternative to gold leafing.
- She continuously scans Pinterest and Instagram to cull imagery to use in her assemblages.

www.ElePackPaintings.com

Ele Pack is a Brighton-based artist who creates ethereal paintings that blend fields of color with contrasting hues, shapes, and lines. With each piece, Pack invites viewers to get lost inside her serene, multidimensional abstract landscapes. Building from layers of various mediums, Pack works with collage, gold and silver leaf, acrylics, and spray paint to achieve a multidimensional, gauzy world of subtle color. Driven by intuition, Pack draws inspiration from both nature and a deeply personal language of form and gesture to inform the contextual and physical components of her work. Moving from this place of intuition, the artist describes her work as simultaneously bold and graphic, sophisticated and raw, tender and emotional.

Floating in Golden [detail], 2015. Spray paint, acrylic paint, pencil, and gold and silver leaf.

Indian Summer [detail], 2015. Spray paint, acrylic paint, pencil, and gold and silver leaf.

Inspired by Paint Itself

Although Pack is traditionally trained as a painter (she received the BTEC [British Technology Education Council] national diploma in art and design, and went on to complete a BA in painting at Loughborough College of Art), her approach to process is void of any specific methodology. Instead, she taps into the language of paint, using the medium to move and inspire her in a range of expression and sensitivity. Pack's floating colors and shapes evolve from an organic process of working with the varying textures and consistencies of different kinds of paint. Acrylic inspires more solid shapes, while spray evokes a gauzy realm that envelops her other shapes and figures. Her self-described paint-driven process helps push each piece beyond the cerebral, evolving as the artist delves more and more into her paintings over time. In some instances, the colors and shapes adorning the canvas have evolved to reflect historically significant motifs and visual trends, adding layers of sentimentality to the work.

Like Snowflakes on Water, 2015. Spray paint, acrylic paint, and pencil.

As Pack's process evolved, she introduced spray paint into her arsenal, attracted to it for its ability to create color fields. She first discovered the medium when experimenting with gold and silver leaf, looking for a way to accentuate the expensive material with a subtler application. Enchanted by the luminescence leafing created, she was curious to see if gold and silver spray paint would complement the soft metallic effect. Pleased with the results, she continues to use a combination of acrylic and spray paints to create a fuller range of texture to complement gold and silver leafing.

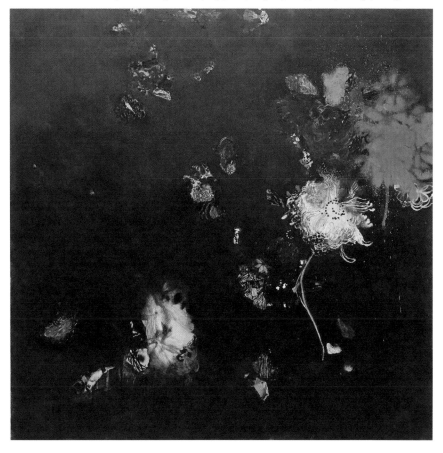

Put a Spell on You, 2015. Spray paint, acrylic paint, pencil, collage, and gold leaf.

Gilded Stencils

With the accompaniment to gold leafing also came the possibility of bringing stencils into her paintings, an interesting contrast to the diaphanous aspects of her work. Unlike other artists, who rely on the stencil for its precise lines, Pack uses stencils and spray to gently repeat imagery and shapes, allowing the spray paint to gather and drip to create soft edges. For Pack, stencils are more of a rough guideline, instead of a reproduction of a particular shape or pattern, used in varying layers of her picture plane. Along with her freehanded markings, her stencils are also inspired by shapes found in nature.

In addition to her open exploration of materials, Pack's conceptual approach to her process is also an ever-changing entity. The artist strongly values intuition as the driving force behind the creation of her imagery, developing her own process through years of experience and trial and error. To add to her internal inspiration and stimulation, the artist surrounds herself with imagery from various sources, including Pinterest and Instagram.

Floating in Golden, 2015. Spray paint, acrylic paint, pencil, and gold and silver leaf.

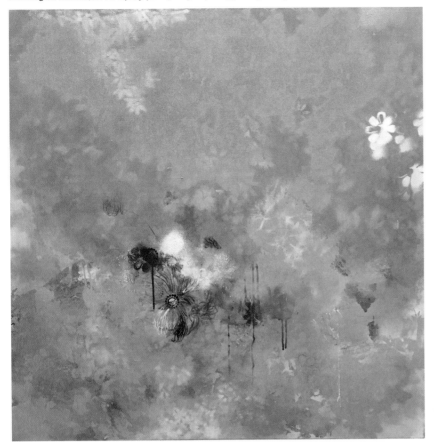

When Angels Sing, 2016. Spray paint, acrylic paint, pencil, and gold leaf.

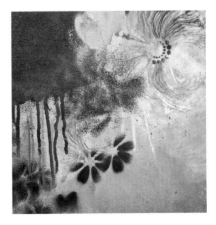

Like Snowflakes on Water [detail], 2015. Spray paint, acrylic paint, and pencil.

Pack has recently devoted herself to creating works that exhibit luminosity, focusing on meticulous layers that are meant to add depth both literally and symbolically. Her paintings are meant to serve as visual metaphors that depict the universal experience of emotion, using swathes of color, fine line, and shapes obscured by layer to illustrate the complicated facets of human feelings. The semiabstract fields of color and shape serve to speak to the viewer on an emotional and sensory level by asking viewers to immerse themselves in Pack's floating clouds of electric emotion.

With the inclusion of spray paint, Pack has been able to expand her work, both figuratively and literally. With spray, the artist can cover large areas of her canvas quickly, which has helped her increase the size and scale of her projects. She recently finished a commission that was 20 by 47 ½ inches (50 by 120 cm) and plans to experiment with larger sizes.

Ele Pack has exhibited her paintings both nationally and internationally. Her work has been exhibited by galleries such as Will's Art Warehouse, Fairfax Gallery, and Bonhams in Knightsbridge, and overseas in Germany, Sweden, and the United States.

DANA OLDFATHER

Raw Energy — Cleveland, Ohio

Portrait of the artist. Photo © Rose Marincil.

Factbox

- Linked to Cleveland's artistic resurgence, Dana Oldfather is also known as a dinnerware designer.
- She attributes her artistic talent and skills to her father, a realist oil painter.
- As a child, she found a quiet beauty in the graffiti scrawls on buildings she saw in Cleveland.
- Oldfather uses spray paint delicately, controlling its force with gentle sprays.
- She finds a holistic comfort in the full-body action of spray paint.

www.danaoldfather.com

The flat and colorless plane of a canvas or white gessoed panel holds equal importance to that of paint for Cleveland-based artist Dana Oldfather's mixed media paintings. The daughter of a traditional easel painter, Oldfather is a self-taught mixed-media artist. She embraces the ephemeral qualities of spray paint to help her create dynamic abstract compositions that range from bold, organic shapes juxtaposed with expressive line work, to graphic, solid forms surrounded by billowing fields of color and texture. Her layered technique allows her to explore and celebrate the visual qualities inherent to each medium she uses, and within each piece she strategically applies paint to show gravity, perspective, atmosphere, and light, treating the unpainted surfaces as important negative spaces. Oldfather's work is highly personal and embodies the raw energy she channels during her creative process. Her current body of work emotes her immediate need to create outside of motherhood and builds an emotional diagram of her own anxiety and desire to overcome it.

Cloak and Dagger Diptych, 2015. Oil, ink, and spray paint on linen.

Artistic Home Schooling

Not formally trained, Oldfather cites her father, a realist oil painter, as her first and only real teacher and mentor. With his influence her work is deeply rooted in this tradition as well as the approach of making art purely for the sake of creation. After her home schooling and high school graduation, Oldfather was driven to establish her own artistic voice and mark. Following in her father's footsteps, she set up the easel her father had made for her in her small apartment and began creating. From there she slowly moved into the beginning of her current Abstract Expressionist style. In this period of time she also educated herself about art history, reading any book she could find, with the intention of infusing her work with influences from the contemporary art world. Her work now presents a new articulation of abstraction in contemporary art that is both intimately familiar and entirely new, fused with impressions from the street.

Childhood Graffiti

While Oldfather recognizes the value of each medium, her inclusion and relationship with spray paint is very personal and was inspired by her experience as a child. Like many artists, she first came head to head with spray paint through the graffiti scrawls on the buildings in Cleveland, finding a quiet beauty in the vandalism. The melancholy of her first encounter with spray paint could describe her delicate application of the medium to the canvas and the mood her method evokes.

> "I'm trying to slow the process down. All the layering helps. Even with the exposed surface creeping in at the edges of the picture, I'm making paintings with more meat now than ever before. It feels good and juicy, like they are full of life."

Her multilayered, abstract paintings range in size from a manageable 18 inches (45 cm) to the grandiose 30 feet (9.1 m) and the substrate for each piece is either white gessoed panel or clear gessoed linen. When creating each composition she considers both the negative and the positive spaces and utilizes the natural appearance of the material she's working on as part of her process. Each painting has a self-imposed formula, carefully including a minimum of four different mediums, with multiple layers of each medium at a time. Within each canvas she builds a dynamic interplay between ink bleed, acrylic pour, acrylic rattle can, and brushed oil, each carrying the value of its own unique attribute. Her use of spray paint plays a very specific role within the overall composition.

Through the physical expression of painting, Oldfather is best able to channel emotions of insecurity. It is in this transition from intangible to tangible that she transforms her feelings of dread and insecurity into something she sees as bittersweet, beautiful, and brightened by the shadow it casts, a therapeutic act bolstered by using a brush or depressing the pressurized nozzle of a spray can. Each medium plays an important role in her process, from its application to its tactile quality on the picture plane.

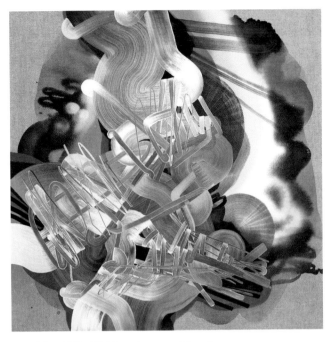

Crestfallen, 2015. Oil, ink, and spray paint on linen.

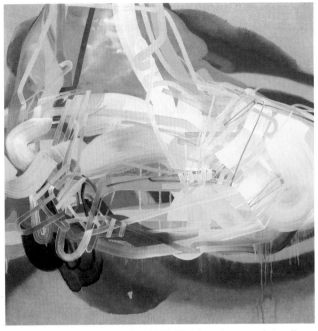

Bra, 2015. Oil, ink, and spray paint on linen.

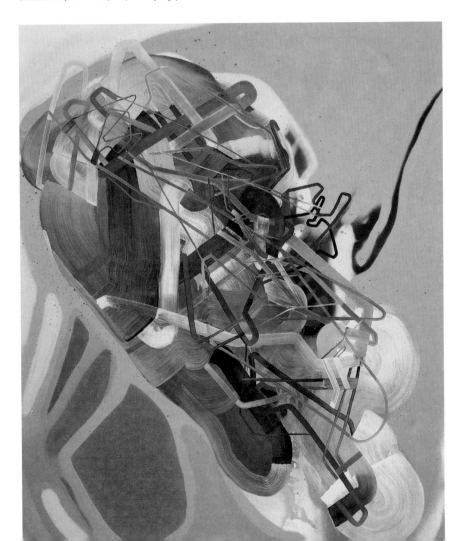

The application of spray satisfies not only Oldfather's desire for abstract line but also the holistic full-body action of spray. Using multiple mediums can sometimes cause the process to take over the actual artwork; with this in mind, she is developing a technique to slow down and let each step and medium have more weight in her final works.

Oldfather has been exhibiting in galleries and museums for over a decade and has work in the POVevolving Gallery in Los Angeles as well as at the Butler Institute of American Art in Youngstown, Ohio. The accomplished young artist was also awarded the William and Dorothy Yeck Award for Young Painters in 2012, and the Ohio Arts Council Award for Excellence in 2013.

I Drove All Night, 2015. Oil, ink, and spray paint on linen.

ARTIST DIRECTORY

BR163
Bronx, New York, USA
www.instagram.com/br163artwork

Zac Braun
Rochester, New York, USA
www.zacbraun.com

Crash
Bronx, New York, USA
www.crashone.com

Matt Eaton
Detroit, Michigan, USA
www.matteatonasnobody.com

Tristan Eaton
Los Angeles, California, USA
www.tristaneaton.net

Elle
Los Angeles, California, USA
www.ellestreetart.com

Casey Gray
San Francisco, California, USA
www.caseygray.com

Conor Harrington
London, UK
www.conorharrington.com

Logan Hicks
Brooklyn, New York, USA
www.loganhicks.com

Hueman
Oakland, California, USA
www.huemannature.com

Will Hutnick
Wassaic, New York, USA
www.willhutnick.com

Joe Iurato
New Jersey, USA
www.joeiurato.com

Ian Kuali'i
Berkeley, California, USA
www.iankualii.com

Dana Oldfather
Cleveland, Ohio, USA
www.danaoldfather.com

Ele Pack
Brighton, UK
www.elepackpaintings.com

PichiAvo
Valencia, Spain
www.pichiavo.com

Remi Rough
London, UK
www.remirough.com

Rubin415
Brooklyn, New York, USA
www.rubin415.com

Tatiana Suarez
Miami, Florida, USA
www.tatisuarez.com

Nick Walker
Bristol, UK and New York City, New York, USA
www.theartofnickwalker.com

While You Were Sleeping by Hueman, 2014.
Spray paint and acrylic on canvas.

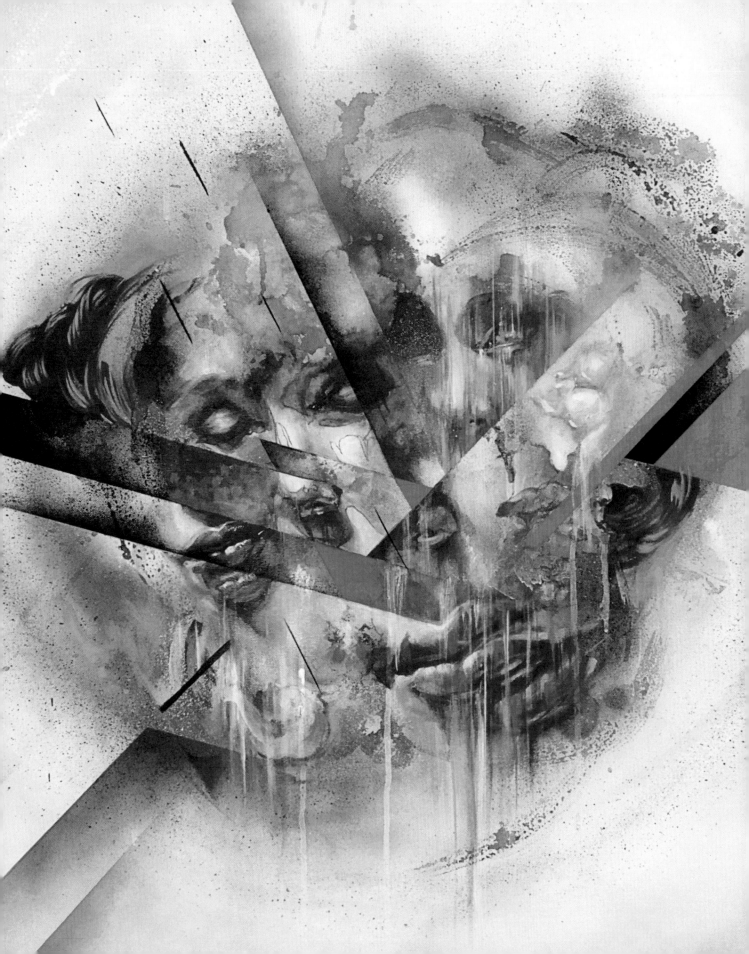

ABOUT THE AUTHOR

Lori Zimmer is a writer and curator who has evolved alongside the public art/graffiti community. She is the creator of the popular blog *Art Nerd New York*, an art history guide to New York City that also provides off beat access to public art, exhibitions, and artists' studios. Since 2009, Lori has been working actively in the art world on many facets, from writing to curatorial projects to advising artists and event planning. Known for mounting exhibitions that often have a narrative thread, she has curated projects for organizations such as Times Square Arts, SCOPE Art Show in Miami and New York, and for the ACT/ART committee for the White House. Zimmer resides in New York City, but travels every chance she gets, visiting artists and galleries across the world.

ACKNOWLEDGMENTS

I'd like to thank everyone who made this book possible: Dawn Nelson, Stefan Walz, John Matos, Anna Matos, Branden Rodriguez, PichiAvo, Joe Iurato , Nick Walker, Tony Sjöman, Casey Gray, Tristan Eaton, Matt Eaton, Allison Torneros, Danielle Reichers, Tatiana Suarez, Conor Harrington, Remi Rough, Will Hutnick, Zac Braun, Ele Pack, Dana Oldfather, Ian Kuali'I, Caroline Caldwell, Rebecca Paul, Lynzy Blair, Jonathan Grassi, Cindy Zimmer, Gil Zimmer, Sailor Hicks, and especially Logan Hicks.

INDEX